D0502420

BARRON'S ART HANDBOOKS

OILS

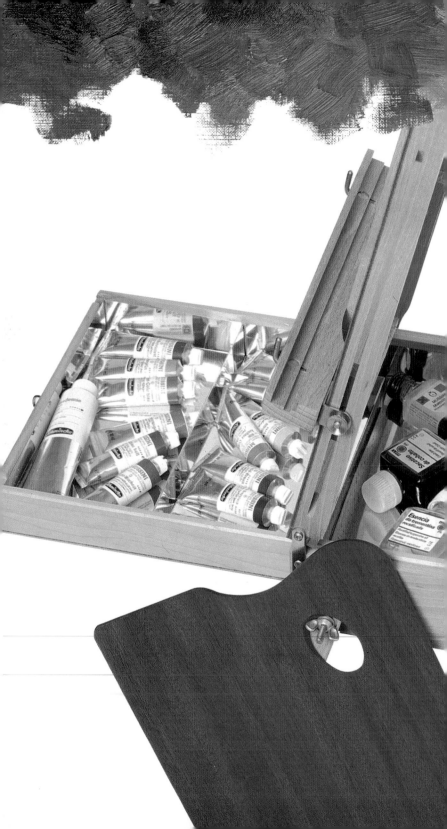

BARRON'S ART HANDBOOKS

OILS

BARRON'S

CONTENTS

TECHNIQUE AND PRACTICE

WHAT IS OIL?

Oil is one of the most the versatile and pliant pictorial mediums at the artist's disposal today. Independently of changing styles, since the fifteenth century, artists have experimented with oil painting, producing works of outstanding beauty while searching out new and expressive techniques.

Linseed oil is the component that lends oil paint a number of unique characteristics when applied to a surface: luminosity, transparency, elasticity, color subtlety, and texture; attributes that can be exploited by the artists according to their needs.

The Medium

We normally refer to the term medium as the material used in creating the works of art, such as oil, watercolor, etc. However, medium also refers to the solvent employed to thin paint. Oil is a fatty medium; that is, the colored pigment comes dissolved in oil plus a series of other substances. But despite

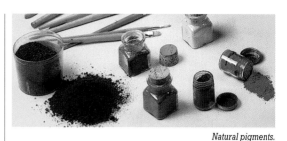

Natural pigments.

Types of oil.

Medium: oil and turpentine.

the relative simplicity of its composition, the manufacturing of oil paint requires in-depth knowledge of the materials used, as well as patience. Linseed oil has an elasticity that dries slowly, and together with a correctly softened pigment, forms the compact and uniform color paste we know as oil paint.

The Pigment

Pigment is the solid component of oil. It is extracted by chemical or mechanical means from mineral and vegetable sources. Pigment is generally powdery in appearance, depending on how much it has been ground. The quality of the pigment depends on its origin and is also gauged by its covering powers which is not to be confused with the size of the area it covers.

The Components

Basically, oil paint is made up of medium and pigment,

but there are also a series of components that produce other results: adding cobalt siccative shortens the drying time; varnish produces a shiny surface, while wax is used to obtain a matte surface. Turpentine, on the other hand, is used as a solvent before drying and also, together with the oil, is one of the main components of oil paints. The painter can experiment with these materials to arrive at any desired pictorial result.

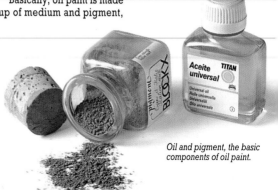

Oil and pigment, the basic components of oil paint.

7

What Is Oil?
A Brief History. Oil Replaces Tempera in Flanders

Woodcut of a painter at work grinding pigment.

Old and Modern Techniques

The manufacturing process of oil paints has changed with the times, incorporating the latest technical advances of each age. Originally, the pigment was placed on a marble pot slab and laboriously mixed with oil until a homogenous and compact paste was obtained. Nowadays, some artists still follow this procedure, while some prefer to use electric blenders (the type used in cookery) or sometimes even an electric drill

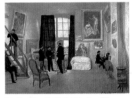

The oxidation of oil particles.

Pictorial layer

Paintings on canvas

adapted for the task. Today, of course, most artists purchase their oil paints in tubes.

A Slow-drying Technique

The oil medium, just as its name indicates, has an oil-based binder. Unlike water-based mediums, oil does not

dry through evaporation. The drying process is produced by oxidation, a chemical reaction with air, which hardens the paint and causes it to dry gradually from the outermost layer to the inner layers.

Linseed oil "breathes" when exposed to the air and dries very slowly, allowing the oxygen to penetrate every particle of paint. This slow-drying process leaves the work in a malleable state for a long period, thus allowing it to be constantly altered.

The Change of Working Surface

Until the invention of oil paints, pictures were gener-

Bazile, The Artist's Studio. *The use of canvas to support oil paint was a technique that significantly increased the artist's output.*

ally executed in water-based paints on rigid supports owing to the fragility of the paint after drying.

The discovery of oil made it no longer necessary to use such heavy and cumbersome supports (although they continue to be used by some artists to this day). A correctly prepared canvas mounted on a stretcher frame is able to support the picture, with the added advantage of weighing much less.

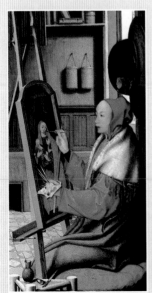

A New Angle of Vision

Until the fifteenth century artists painted their small and medium-sized panels on horizontal surfaces, just as illuminated manuscripts were done. The advent of oil painting made it possible to place the panel support in a vertical position, since the density of this medium prevented the paint from running, a development that improved the painter's angle of vision.

Disciple of Quintin Massys, Saint Luke painting the Virgin and Child.

A BRIEF HISTORY. OIL REPLACES TEMPERA IN FLANDERS

The oil paints we know today, packed in tubes which make them easier to store and transport, are almost identical to those used at the very start. Despite the quality of the oils employed and new synthetic pigments, oil has not undergone any significant changes.

Introduction of Oil Paints in Italy

Oil paints were first used during the late Middle Ages in Flanders. One of the pioneers of the oil medium was the Flemish painter Van Eyck (1390–1441). Almost a century later, it was introduced to Italy, most probably through certain miniatures from Flanders. The impact of the medium and its rich color was such that by the sixteenth century it had become the paint of choice. It was not only the Flemish masters who were able to paint everyday scenes and portraits for the emerging bourgeoisie, but artists from all over Europe. Court painters quickly adapted themselves to this new medium that brought unprecedented realism to the art of portraiture.

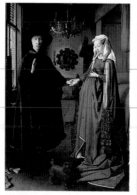

Van Eyck, The Arnolfini Marriage. This painting is an outstanding example of the introduction of oil to Italy.

A Time-honored Tradition

In spite of the development of different creative directions throughout history, oil has definitively established itself on the palettes of most artists. Although nowadays oil is associated with traditional painting, it was synonymous with modernity and development in art in the past.

Oil's Advantages Bring About the Decline in Tempera

Until the emergence of oil paints, artists painted their works in

tempera, bound either with egg or gum. When oil was introduced from Flanders, the most common techniques used by painters were tempera with egg and fresco painting on wet plaster, but they lost no time in adapting to the new medium. Oil had innumerable advantages over tempera: the color took longer to dry, which meant that mixing and touching up

Some of the components of tempera painting.

could be carried out almost continuously; once dry it appeared glossy and elastic, lending the picture a chromatism that enriched it with a more realistic appearance. Furthermore, the greatest impact of this new medium was the way in which the depth of the color allowed it to retain a fresh look once dry.

A jar of earth pigment.

Oil and The Discovery of Perspective

During the Italian Renaissance, discoveries and inventions were made that had profound repercussions. The invention of perspective, first used by architects of the time, was quickly adapted by artists to create the illusion of a third dimension on a flat

What Is Oil? 9

A Brief History. Oil Replaces Tempera in Flanders

The Composition of Oil. Resins, Pigments

Raphael, Betrothal of the Virgin. *This painting is a fine example of the use of perspective.*

Oil Replaces Tempera

In 1200 Theophile Rugierus wrote a treatise on painting called *Diversarium Artium Schedula,* in which he recommended the use of linseed oil and gum arabic. Until the year 1410 artists painted in tempera, until then the only known technique available for painting miniatures, illustrations in manuscripts, icons, painted panels and murals. Some tempera painters applied a coat of linseed oil over the picture to obtain a shine and increase its chromatism.

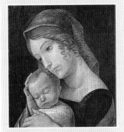

Mantegna, Virgin with Child. *One of the first oil paintings.*

sessions, something that was difficult to do with tempera. The fact that the paint remains workable from the moment it leaves the factory to the time it has dried on the canvas permits the artist to paint all manner of color gradations without the changes in color and value produced during drying.

Effect of Light on Paint

Generally, colors deteriorate to different degrees depending on their composition when exposed to

Different ranges of oil paints with their different color gradations.

light. Oil is one of the mediums that is least affected by photosensitive phenomena because the oil molecules protect and thus stabilize the pigment. On the other hand, tempera paint, despite its original luminosity, tends to gradually deteriorate with prolonged exposure to light. At first this characteristic was not taken into account, but became evident with the passing of time.

plane. Brunelleschi, Leonardo da Vinci, Andrea Mantegna, and other great masters of the period used the oil medium to study the chromatism of bodies in space, their depth, and shadows.

Flesh Colors and Drapery

The advent of oil enabled artists to resolve two of the most challenging problems of painting: flesh colors and drapery. This difficulty was due to the limitations in blending fast-drying colors together. With the introduction of oil medium, the folds and creases of fabric and the subtle variations in skin tones that artists were able to attain marked an unprecedented advance in the history of painting.

Color Gradation

Thanks to its density and texture, oil can be employed to create a wide range of color blends and gradations, enabling the artist to paint a picture in any number of

1. The color of the drapery is applied lightly.

2. The shadows are darkened with a second layer of red.

3. A final lighter layer highlights the shines.

MORE INFORMATION:

Oil colors and their pigments **p. 14**

Different name brands of oil and their quality **p. 18**

The preparation of different surfaces **p. 24**

THE COMPOSITION OF OIL. RESINS, PIGMENTS

Although the composition of oil paints is simple, each one of the components that go to make it up is both complex and delicate. It is therefore essential to know how to apply them correctly and obtain a satisfactory result. The resulting color will be influenced by the medium's transparency and often by some characteristics of the color itself.

Type of Oils

Linseed oil is essential in the manufacture of oil paints. It is obtained from grinding up linseeds, which leave a yellowish viscous material that is ready for use as an oil medium. This unrefined oil does not change the color, except for the lighter pigments, which exert a yellowing effect when the paint has dried.

Refined linseed oil has a cleaner and lighter tone and livens up colors instead of altering them when mixed with pigment. The quality of the oil varies according to the brand. Some brands contain a certain amount of cobalt siccative, so that once mixed with the pigment it is ready for use. It is essential to know how to use this product correctly, otherwise you may have difficulties in controlling the drying time of the oil.

Consequently, many artists prefer to employ oil without siccative, which gives them total control over drying

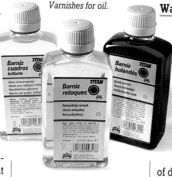
Varnishes for oil.

time. You can also use slow-drying oils and walnut oils.

Varnishes

Varnish has always been an invaluable aid for the painter. There is a wide variety of varnishes to choose from, but the most commonly used type is a natural resin called Dammar, which, slowly diluted in a water bath and then in turpentine is completely compatible with oil, producing a shine after drying.

There are other types of protective varnishes that are applied over oil once it has totally dried, each brand having its own different quality. If the painting requires it, a quality product should be applied.

Naturally, the question of whether to use a varnish is purely optional.

Wax as a Special Additive

Oil does not necessarily have to be glossy. One of the potentials of this medium is its capacity to be worked with different types of mediums. Not only does it provide magnificent glossiness, it also allows for a range of deep and delicate opaque colors. Beeswax diluted in

Wax.

turpentine is an excellent component for giving oil colors a rich matte quality. This product can be bought in art supply stores.

Wax provides a velvety quality and enables the artist to obtain deeper tones than those achieved with other mediums.

On the other hand, if a small amount of wax is used, any great difference in glossiness will disappear after drying.

Linseed oil and walnut oil.

The First Techniques

The first oil paintings that possessed an impressive range of tones and color blends were executed almost exclusively with glazes. That is, starting out with a detailed initial drawing done with a fine brush and *verdaccio* (a mix of white, black, and ochre), a fine layer of ochre was then applied on top in order to intensify the picture's values in monochrome. The painter would begin by painting the drapery, moving on to the architectonic forms, and leaving the face and hands for last.

Bitumens and Glazes

Glazes are transparent layers of paint applied to an area of the painting with the aim of altering a color that has already been applied. Much practice is needed to master this technique.

Some types of oil-based mediums, like bitumen, are used to obtain monochrome tonalities. Such is the case of Bitumen Judea, which, when dissolved in turpentine like any other fat medium, behaves like a glaze de-pending on how densely it is applied.

Bitumen Judea.

Oil Glazes

This type of glaze is the most common. It consists of adding oil in order to attain the desired transparency. A tiny amount of oil color is dissolved in the oil and a lightly colored transparent glaze is obtained.

Cobalt siccative.

Cobalt Siccative

Cobalt siccative accelerates the drying time. This product can be found in art supply stores. Its cobalt derivative speeds up the oxidation of the oil, when exposed to air, (from the exterior to the interior of the paint). This product makes the entire layer of paint dry evenly. Incorrect usage can cause irreparable damage to the paint. Many art supply stores sell linseed oil with cobalt siccative incorporated in it. Oil paints sold in tubes also contain siccative.

Adding cobalt siccative.

Types of Pigments

The color of an oil paint is determined by the pigment. It may be mineral in origin, such as the earth colors, derivatives of oxides, titanium white, and the cadmiums. There is also the vegetable variety, extracted from coal and other vegetable derivatives from which carmine-like colors, and certain yellows and greens are obtained. Furthermore, there exist organic pigments, obtained from insects. Animal pigment colors are scarce and expensive, and are mainly used in the cosmetic industry. Generally, the cost of pigment determines the quality of the oil, its covering power, and viscosity.

Pure pigments.

MORE INFORMATION:

What is oil **p. 6**
Grinding oil **p. 12**
Oil colors and their pigments **p. 14**

GRINDING OIL

Although artists have prepared their own paints from time immemorial, most artists nowadays prefer to buy them ready-made in handy tubes and jars. On the other hand, some experienced artists do prepare their own materials. Even if you do not prepare your own paints, it's useful to know how it is done. There are no hidden secrets to making paint, all it requires is time and a certain amount of knowledge.

Materials for Manufacturing Good Oil Paints

Paint can be prepared at home, but bear in mind that pigment is a volatile substance. The work is not necessarily messy if you take the appropriate measures, such as covering your work area with newspaper and having several cloths handy for cleaning spills and, of course, a well-ventilated workplace without drafts that might scatter the pigment. To prepare some good paint you will need the following materials:

• *Color pigments.* These can be bought in art supply stores. They are sold in jars or packets by weight. The price depends on the quality of the pigment.
• *Linseed oil.* Rectified and containing cobalt siccative or not. It is sold in bulk or in small jars.

• *Beeswax.* A small amount is enough to begin with. A good substitute is Dorland's Wax Medium.
• *Turpentine.*
• *A mortar and pestle.*
• *A slab of glass or marble.*
• *A wide palette knife.*
• *Several jars with tops.*

Grinding the Pigment

First you have to decide how much oil you need. It is preferable to start with small quantities. If the pigment is not fine enough, it will have to be ground to prevent lumps from forming when the oil is added. Place the pigment in the mortar and, with the pestle, grind with slow circular movements of the wrist, applying constant pressure against the bottom. If you are going to prepare several colors it is recommended that you finish one color before starting on the next.

Diverse Densities of Pigment

Not all pigments possess the same consistency or density; therefore, it is essential to make sure that the pigment is ground as finely as possible before it is mixed with oil.

Glass or Marble

The mixing of the pigment and oil is carried out on a smooth nonporous surface, such as a slab of marble or a sheet of glass, both of which are ideal for this task.

Marble is more commonly used than glass because it is less fragile. If you do decide to use a slab of glass, it should be at least 7-mm thick to prevent it from cracking under the pressure of the mixing, and it must be placed on a smooth, flat surface.

PREPARATION OF OIL PAINT

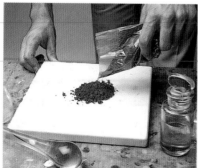

1. Place the pigment on the slab of marble.

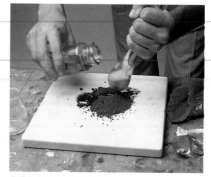

2. Grind the pigment with oil.

Oil Paint Containers

The process of storing oil paints has undergone many changes throughout time. The first containers were made of a skin bladder, which gradually developed into a glass vial. The collapsible metal tube we know today was invented only a hundred years ago.

The First Mix

Place some pigment in the center of the marble slab (three soup-spoonfuls) into a heap, then taking the utmost care, pour a spoonful of medium (linseed oil and turpentine in equal parts) and press them all together with a spatula or palette knife.

Note how quickly the oil saturates the pigment; because the saturation level of oil is so high, the amount of oil you will be using should be much less than the amount of pigment. Continue grinding and mixing the color to eliminate lumps. Do not apply any more medium until the pigment has fully absorbed the first application.

Mixing

Gradually and carefully add more small quantities of medium, avoiding saturation. The mix of pigment and oil should gradually acquire a more compact consistency. Once it has reached a yogurt-thickness, start mixing it using the spatula or pestle, grinding the pigment against the surface until a homogenous paste is obtained.

Adding Other Ingredients

Once you have obtained the correct density, similar to that of toothpaste, add, if it is desired, several drops of Dammar varnish or cobalt siccative. Do not abuse the cobalt siccative, three or four drops for each three spoonfuls of oil are ample for accelerating the drying time.

Storing the Oil and How to Preserve It

Once you have made enough oil paint, store it in appropriate containers. Use the flat side of the spatula to scoop up the paint and then run it over the rim of the opening to force it inside.

If you do not plan on using the paint right away, immerse it in water. This stops it from coming into contact with the air and consequently drying.

The oil medium maintains the color's stability once it has dried.

MORE INFORMATION:

What is oil **p. 6**

The composition of oil. Resins and pigments **p. 10**

Oil colors and their pigments **p. 14**

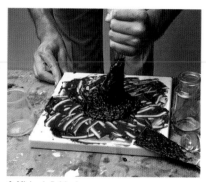

3. Mixing is finished.

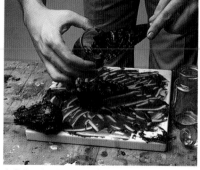

4. Collect the pigment.

OIL COLORS AND THEIR PIGMENTS

Oil colors, like the colors of all other paints, depend on the pigment they are made of.
The mineral or organic components of oil endow it with a number of distinct characteristics,
such as opacity, luminosity, covering power, and drying power. Oil colors are divided
into whites, yellows, reds, greens, blues, browns, and blacks.

White Colors

Depending on its origin, this color may consist of lead white, zinc white or titanium white.
• *Lead white* (white from lead) has extraordinary opacity and fast drying time. It is highly toxic,and allowing it to come into contact with your skin or inhaling it can have serious consequences.
• *Zinc white* dries more slowly but covers less well than silver white.
• *Titanium white* has a rapid drying time with good opacity, which is the reason why it is the most commonly used.

Yellow Colors

• *Naples yellow* is very popular for painting flesh colors; is opaque, dries well and, like all other lead colors, it is highly toxic.
• *Chrome yellow* is derived from lead and therefore very toxic. It is opaque and dries well, but offers little resistance to light.
• *Cadmium yellow* is a rather slow-drying color. It has a powerful and bright tone that can be mixed with all other colors, except those derived from copper. It is available in several hues.

• *Ochre yellow* is an earthy color, with great covering power and permanence. It can be mixed with all colors.
• *Raw sienna* originated from the earths of Siena, Italy, and is the earthiest of the yellows. It is a strong color that covers well but may darken over the years.

Red Colors

• *Burnt sienna* has similar characteristics to the above-mentioned raw sienna, but darkens to a lesser degree.
• *Vermilion,* bright and slow drying, when exposed to

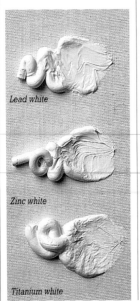

Lead white

Zinc white

Titanium white

Chrome yellow

Cadmium yellow

Ochre yellow

Raw sienna

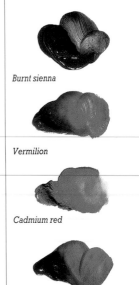

Burnt sienna

Vermilion

Cadmium red

Rose madder

light for some time has a tendency to darken. It is not advisable to mix it with lead white or copper derivatives.

• *Cadmium red* is a bright powerful color, which substitutes advantageously for vermilion, since it is not sensitive to light.

• *Rose madder* is a very potent color supplying a rich tonal range. It is rather fluid, dries slowly, and is excellent for glazing.

Greens and Blues

• *Permanent green,* a pale, luminous color, is resistant to light, covers well, and can be mixed with all colors. It is available in several hues.

• *Terre verte,* a brownish tone, derived from ochre, covers well and dries fast.

• *Emerald green* or *viridian green* is bright, permanent, and covers well.

Permanent green

Emerald green

Cobalt blue

Ultramarine blue

Prussian blue

• *Cobalt blue,* metallic in origin, but not toxic. This color covers well and dries fast, which may cause it to crack when it is applied on surfaces that are not quite dry.

• *Ultramarine blue,* it mixes with all other colors, has a normal opacity and drying time, and is warmer in tone than cobalt blue.

• *Prussian blue* is a color of great staining power. It is transparent, dries well, but is so sensitive to light that it may fade (with the peculiarity that the color regenerates when left in the dark for some time).

Browns

• *Raw and burnt umber* are both natural earth colors. Both tend to darken with time. They dry very fast; do not apply them too thickly, to prevent cracking.

• *Van Dyck Brown* is dark with a grayish quality and cracks easily.

MORE INFORMATION:

Different types of oil, qualities, and brands **p. 18**

Color blends **p. 62**

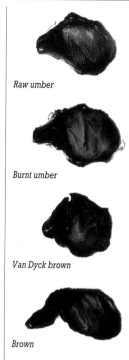
Raw umber

Burnt umber

Van Dyck brown

Brown

Blacks

• *Lamp black* is a cool color that can be mixed and applied in any manner.

• *Ivory black* is a darker and warmer black with all the same qualities.

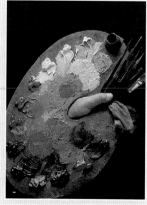

Oil Colors

The most commonly used oil colors by professionals are:
Titanium white
Cadmium lemon yellow
Cadmium yellow medium
Yellow ochre
Burnt sienna
Burnt umber
Vermilion
Rose madder
Permanant green
Emerald green
Cobalt blue
Ultramarine blue
Prussian blue
Ivory black

SPECIAL ADDITIVES: WAX, BINDERS, AND VARNISHES

By manufacturing your own oils you can include a series of characteristics that cannot be found in the ready-made products sold in art supply stores. These attributes require much time and experience; therefore, the additives need to be tested out and compared before they are put to use.

Beeswax

Beeswax, available in art supply stores, gives the paint a semi matte finish, reducing shines to a velvety satin.

The use of beeswax and oil is not very common among painters, since it requires a painstaking preparation. The wax can be bought in blocks or grains, the latter being much easier to melt. It is heated in a water bath and, when it has melted and while maintaining the same heat, a touch of turpentine is added to slow down

A. Linseed oil.
B. Poppy oil.
C. Walnut oil.

Melting the wax in a water bath.

its hardening. A few drops of wax are enough to alter the quality of the hue.

The Quality of Manufactured Oil

The artist can choose from a wide range of manufactured oil, depending on what he or she intends to use it for. There are oils of an exquisite transparency that benefit the chromatism of the pigment. The most widely used oils are linseed oil, poppy oil, and walnut oil. Linseed tends to be the most popular with painters, but poppy oil is also good for obtaining trans-

parencies, although its dries somewhat slowly. The rest of the additives that comprise oil paint also determine its quality. If you want a quality oil, you should use quality products.

Solubility and Solvents

Oil medium is soluble in turpentine, oil, and varnish; likewise, it can be mixed

Oil and turpentine.

with wax and all manner of additives and pigments. The final result will depend on what additives have been incorporated during its manufacture.

Retouch Varnish

The main difference between retouch varnish and protective varnish is that the first is made up of synthetic resin and volatile solvents, which makes it dry fast giving the surface a uniform gloss. Retouch varnish is

Retouch varnish.

used to bring out dull areas in order to return the shine and original intensity of the colors.

Protective Varnish

This varnish is applied to the picture when the paint has completely dried. The time a painting takes to dry depends on the thickness of the layer, normally at least a year, depending on the humidity and warmth of the place where the picture is left to dry. Bear in mind that

oil does not dry through evaporation, but through oxidation; therefore, it is best to dry a work in a dry and ventilated area.

Gloss and Matte Varnishes

There are two types of protective varnish: gloss or matte. Matte varnish solves the annoying problem of the reflection of light from the surface of the work; nonetheless, it should be taken into account that its use reduces the intensity of the colors to a certain degree. Varnishes can be purchased in bottles or in aerosol sprays.

Dammar Varnish

Dammar varnish is the most common resin employed in oil and is ideal for use in mixing paint. Dammar is a resin extracted from tropical trees such as *Shorea* and *Hopea*.

The best solvent for this varnish is turpentine. The correct proportions are 67 ounces of turpentine for every gallon of varnish.

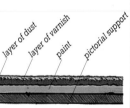

The varnish protects the canvas from external agents, such as dust, dampness, etc.

Heavy Over Thin

To prevent a painting from cracking with time it is essential to paint the first layers with a greater amount of turpentine than the subsequent ones, but without the oil losing its characteristic consistency.

If your second layer of paint is thinner than your first, cracking will eventually result. It is a question of adhering to the rule of "fat over lean."

Dammar varnish.

Dammar varnish is prepared by dipping it into a container filled with turpentine.

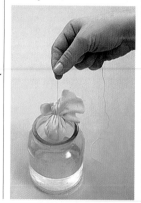

DIFFERENT TYPES OF OIL

All good art supply stores sell a great number and range of oil colors, qualities, and prices. Even within a specific brand different grades of quality are available at different prices.
Very often certain brands are synonymous with quality, that is, they guarantee that the ingredients contained in the product are pure.

Qualities Within Brands

Nowadays even the lesser known brands manufacture fairly good quality products. The difference depends largely on the amount of additives (not pigment) that the paint contains; that is to say, the quality of the paint depends on the concentration and purity of the pigment from which it is made.

Logically, the high quality colors possess greater covering power and color intensity than the more economic ones.

The more expensive oil paint is usually cheaper in the long run. For example, a quality cadmium yellow will last up to seven times longer than an inferior version.

Quality According to Your Needs

When we come to paint a picture, the quality of the products that we are going to use will have a decisive influence on the development and finish of the work, so never use anything less than

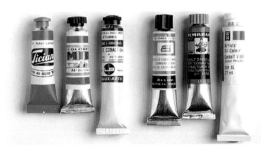

Different types and qualities of oil paints.

medium quality paints. Lower quality and school paints produce poor results, the color turns out rather dry, and cracking often occurs once the paint has dried. For these reasons it is wise to select a paint according to what you wish to achieve. For instance, if we want to paint sketches or notes that do not require much more than simple lines and washes, there is no need to use quality paints.

To Buy or to Make?

The manufacture of oil is a task that requires much skill and patience, but, once you

have learned the technique, you will be able to manufacture paints of the highest quality.

One advantage of making your own paints is that you have absolute control over the procedure. The paint's density can be altered in order to make it more or less glossy and value and tone can be controlled according to your taste.

On the other hand, some colors are very delicate and therefore can be difficult to manufacture.

Certain pigments darken excessively when they come into contact with oil and require additives to reduce their density. The use of such

Different fluid colors.

additives can destroy the gloss and intensity of the color; therefore, it is recommended that you buy these more delicate and expensive colors in tubes.

Volumes and Needs

The amount of paint you need depends very much on what you are going to paint. Because paints are sold in 0.7 oz. to 6.75 oz. tubes, consider carefully how much you really need before painting. One consideration to bear in mind is that we do not use in the same quantity of a special color with the same frequency. White, for instance, is one of the most widely used colors in oil, so it is recommended you buy tubes of 6.75 oz.

Conversely, some colors such as cadmiums are used in small amounts and consequently you should buy only small or medium-sized tubes.

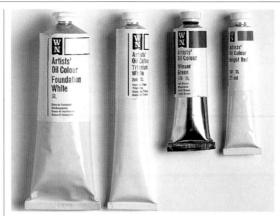

Compatibilities and Quality Mixes

Oil colors can be mixed together regardless of the brand. Nevertheless, it is important to calculate how compatible they will be with certain cobalt-derived paints.

Medium quality paints sold by recognized manufacturers normally provide good results, and their high quality paints provide extremely rich tones.

Oil Mediums

When you are considering different brands of oil paints, it is essential to have an oil medium for enriching the mix. In this case it is important to choose a high quality label that does not contain cobalt siccative.

If you decide to do this yourself, use a good walnut oil and the best quality turpentine.

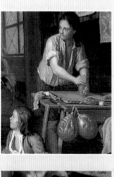

José Oremans, The Painter's Studio (detail).

Guilds protected and controlled the different professions and trades, and the painters guild was equally as rigorous with its members as any other guild, to such an extent that to prove his mastery, the aspiring painter had to spend several years grinding pigment, manufacturing paints, and doing other menial work. Nowadays most artists work with paints manufactured by paint companies.

The original method of manufacturing paints (top) has been substituted by industrial production (bottom).

MORE INFORMATION:

The composition of oil. Resins and pigments **p. 10**

Oil colors and their pigments **p.14**

PREPARING DIFFERENT SURFACES: CANVAS

It is indispensable to have a good surface for painting in oil. Oils can be applied over practically any surface, but the result of your work will be decidedly conditioned by its condition. A deteriorated support, for instance, may cause the colors to lose their shine, appear lifeless, and take on a cracked appearance. It is possible to prepare almost any surface to paint on in order to ensure that the oil colors will retain all their characteristics after drying.

Stretcher Measurements

Individual stick sizes range from 8 inches and up to 84 inches and can be combined to form any proportion. Premounted canvas is also available at art supply stores. You should also be aware that there are three international stretcher formats used by most large manufacturers. Note that the metric system is used. The sizes range from a No. 1 to 120; for instance, a number 1 figure format measures 22 × 16 cm, the landscape 22 × 14 cm, and the seascape 22 × 12 cm.

International Stretcher Sizes

No.	Figure	Landscape	Seascape
1	22/16	22 × 14	22 × 12
2	22/19	24 × 16	24 × 14
3	27/22	27 × 19	27 × 16
4	33/24	33 × 22	33 × 19
5	35/27	35 × 24	35 × 22
6	41/33	41 × 27	41 × 24
8	46/38	46 × 33	46 × 27
10	55/46	55 × 38	55 × 33
12	61/50	61 × 46	61 × 38
15	65/54	65 × 50	65 × 46
20	73/22	73 × 54	73 × 50
25	81/65	81 × 60	81 × 54
30	92/73	92 × 65	92 × 60
40	100/81	100 × 73	100 × 65
50	116/89	116 × 81	116 × 73
60	130/97	130 × 89	130 × 81
80	146/114	146 × 97	146 × 90
100	162/130	162 × 114	162 × 97
120	195/130	195 × 114	195 × 97

Different qualities of canvases.

Choosing the Canvas

The best canvas for use with oils are made of linen or cotton, the former being the most expensive and more permanent. Linen is distinguished from cotton by its stiffness and vegetable color. Canvas, as a painting surface, has a characteristic grainy texture, which varies from very rough to very smooth, depending on the thickness of the strands in the weave. When you come to choose a canvas, think about its purpose. Some canvases are sold exclusively for use with oil paints, for combined techniques (acrylic and oil), or exclusively for acrylic paints. There are also "raw" canvases, which need to be primed according to the paint we want to apply on them.

Stretching and Mounting

The canvas has to be stretched and mounted before it can be primed or painted on. Depending on the type of stretcher chosen, you will need to leave a margin of about 3 inches so that it can be folded around the frame firmly and secured. The canvas is stretched by fastening a staple in the center of each side, then stapling out from each center, equally, toward each corner. It is essential to not allow any folds or creases to form. Finally, the corners have to be folded over and stapled.

Rabbit Skin Glue

One method of priming a canvas is to apply rabbit skin glue over the surface. This

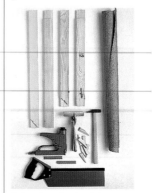

Strips of wood and tools for preparing a support.

Strip of wood.

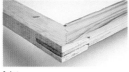

Joint.

How Leonardo Painted

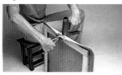

The corners are left for last.

Stretching the canvas.

Leonardo da Vinci primed his canvases and panels with a broken color, either gray or brown and occasionally pale *verdaccio*, colors that were the result of leftovers of paint the artist has manufactured himself. The primer was used to create a type of draw-painting, integrating the background with the figure by means of subtle *sfumatos*.

Attaching the corners.

The finished product.

product can be bought in art supply stores. The glue must be prepared in the following way: leave about a pint of glue to stand for twenty-four hours in warm water in order to soften it. Then heat the water bath until the glue has completely diluted.

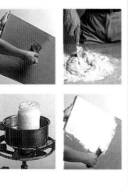

Sizing and Priming a Canvas with Glue

Three or four coats are applied over the raw canvas while the glue is still warm and then it is left to dry. Once dry, prepare the following mix:
One part of calcium carbonate.
One part zinc white.
One part glue.
Two parts water.

Mix calcium carbonate with zinc white and water until you obtain a creamy paste. Heat the glue in a water bath. The result is applied to the canvas in three layers, each in a different direction.

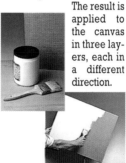

Latex and Acrylic

A faster way of priming the canvas is to use ready-made glues and resins. There are many types of primers available; although they may not be as traditional as rabbit skin glue, they have the advantage of being convenient and quick. Plastic and resinous primers are applied quickly and lend the canvas a homogeneous and elastic finish. The first coats are applied in liquid form to seal the surface. Once these have dried, denser coats, mixed with calcium carbonate can be added.

Priming a Canvas with Gesso

Gesso requires no further additive. It is applied directly to the canvas as it comes from jars and, thanks to its density, can be used to create texture on the canvas.

Priming a Canvas with Turpentine

An excellent primer for painting in oils comprises 17.5 ounces of lead white and 5.5 cubic inches of turpentine. This paste has to be applied in a uniform and dry manner over a period of two or three days. Finally it is sanded down and a new coat is applied. This is essentially a European method, since U.S. manufacturers are discouraged from using lead in their products.

MORE INFORMATION:

What is oil **p. 6**
Stretching the canvas **p. 35**

PREPARING DIFFERENT SURFACES: PAPER AND CARDBOARD

In addition to painting on canvas, almost any other type of material can be used provided it has been primed appropriately. The main reason for priming a surface is to isolate the fiber it is made of from the oil of the paint, which would otherwise decompose it. On the other hand, there also exist rigid panels that come ready to work on.

Qualities of Paper

Both paper and cardboard are good surfaces for painting in oil. There is a great variety to choose from, some of which are more appropriate than others. Paper is either made of cellulose (derived from wood) or vegetable fibers like linen or cotton, and it is industrially manufactured or made by hand, the latter being much more expensive but also much more attractive. Paper is usually coated to a greater or lesser degree, depending on what it is meant for; nonetheless, it has to be primed if it is to be put to use with oils.

Canvas-covered Paperboard

Made especially for oil painting, canvas-covered paperboard is a practical support for painting. In general,

Hand-made paper.

Fabric-covered paper.

it comes in small formats, the sizes of which correspond to the standard stretcher measurements. This type of rigid cardboard is made with primed canvas glued on top. Among the formats that can be bought there are sizes that fit inside a paint box, a fact that makes it suitable for outdoor use.

Tensing Paper

When priming paper, it is useful to pull it tense in order to stop creases from forming. If the sheet of paper you are going to use is thick enough, you can simply fasten it to a drawing board with push pins. Thin paper should be prepared as follows: wet the paper to open up the pores and dilate the fiber; then attach the wet paper to a board or smooth surface with scotch tape, all the time making sure that no creases form. The fiber contracts once the paper is dry and reverts to its original character.

The Paper Surface

Since paper is not very rigid it requires priming before it can be used for painting. If you use it for painting fast notes, it only has to be

How to stretch paper.

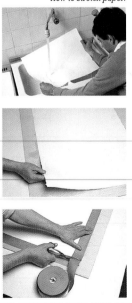

Preparing Different Surfaces: Canvas
Preparing Different Surfaces: Paper and Cardboard
Preparing Different Surfaces: Wood, Masonite

23

attached to a drawing board or similar hard and smooth surface with push pins. Paper can also be mounted and stretched on a stretcher in the same manner as canvas. The process is simple, but remember that it should be done after the surface has been primed. The stretcher

You can rest the paper on any flat support.

Cézanne and Cardboard

Cézanne painted 55 pictures of Saint Victorie from the window of his house, all of them different, even though the theme is the same.

Some of these works were painted on cardboard; this material was very common with artists because it was rigid, light, and cheap.

How to mount a piece of paper on a stretcher.

is placed on top of the wet paper. The corners are cut and folded over each side of the stretcher, fastening them down with masking tape. The paper will stretch firmly once it is dry.

Sized Paper

Generally, during the manufacture of sized paper, a certain amount of glue is added to bind the pulp from which it is made. Some paper contains more glue, a component that makes it more rigid and suitable for standing up to rough treatment. This type of paper tends to be thicker and the best is hand-made, which makes it much more expensive. At any rate, the fact that the paper has been sized does not mean it should not be primed before it is paint-

ed on, since the paper fiber must never come into direct contact with the oil paint. There must always be a thin layer between the paint and any surface.

Priming Cardboard

There is also a wide variety of types and textures of cardboard to paint on. In

Priming with oil.

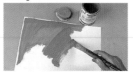

Priming with latex.

fact, any cardboard is suitable, but it is equally important to prime it in order to prevent the cardboard from absorbing the paint. To prime a piece of cardboard, you should first fasten it to a firm surface with staples and apply an initial coat of soft glue. Once it has dried, apply another coat, this time containing a little calcium carbonate and zinc white. Each coat should be applied in the opposite direction.

The Possibilities with Latex

Latex is a thin vegetable resin that has enormous plastic potential both for its elastic capacity and its transparency. It can be used as a primer and as an underpainting for use with oil paints. It is sold in art supply stores, and can be diluted in water.

Color papers.

Ready-primed paper.

MORE INFORMATION:

Priming different surfaces: canvas **p. 20**

Other primers: latex, acrylic, and derivatives **p. 28**

PREPARING DIFFERENT SURFACES: WOOD, MASONITE, AND CONGLOMERATE

Long before canvas was first used as a surface, all pictures were painted on wood, the only surface available at the time. It was very impractical to transport due to the weight. Like all other surfaces, wood has to be primed before painting.

• •

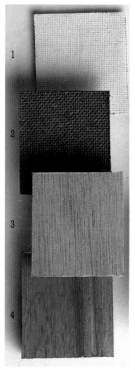

1. Canvas-covered cardboard.
2. Masonite. 3. Plywood.
4. Oak panel.

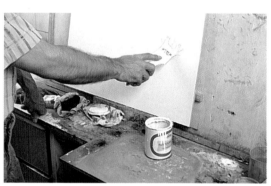

Preparing a surface with filler.

Priming Different Surfaces

Both masonite and plywood need to be primed before painting over, in order to isolate the surface from the layer of paint. Masonite is a synthetic conglomerate. It is easy to prime since one of its surfaces is smooth and has rather closed pores; several coats of latex with calcium carbonate and lead white are enough to provide it with a surface suitable for painting on. Plywood and wood require special care; since both surfaces are made of wood fiber, they are vulnerable to contact with humidity and other atmospheric factors. Great care must be taken in the right choice of a natural surface. It should not have heavy veins, knots, or other irregularities.

Filler

The surface you are going to paint on must be protected from coming into contact with the oil paints, but there must be a space to breathe between the two. Therefore, the surface is sealed with an application of filler which, once dry, is sanded down.

Filler is available in containers and can also be made from alcohol and rubber lacquer.

Calcium Carbonate

Calcium carbonate is mixed with glue to prime canvas. Its alkaline quality on coming into contact with a wet medium turns it into a homogenous paste. This mix can be applied with a brush. This application is employed in the same way as we have

A bottle of liquid filler.

mentioned earlier, coating in successive layers, alternating the direction of each coat, and sanding each layer once it has dried.

Smoothing down the Surface

Sanding down the surface is one of the most important phases when preparing wood. The choice of sandpaper will depend on the roughness of the surface's texture, but if you have applied the successive layers correctly, it is just a question

have applied four or five coats, always remembering to alternate the direction of the stroke and allowing the coat time to dry before smoothing it down and going on to the next coat. The

a No.2, and so on. Smooth surfaces must be primed until they acquire the body of a prepared surface.

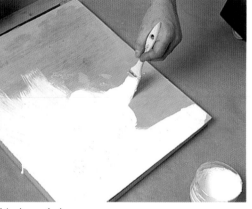

Sanding down wood.

Eighteenth Century Wooden Panels

The Italian painters of antiquity used the wood of the poplar tree. Nordic painters from the eighteenth and nineteenth centuries preferred mahogany, while English artists used panels made of laminated wood, which is much more resistent to deformations and warping.

Applying layers of color.

of rubbing softly with fine sandpaper in circular movements to obtain a surface as smooth as glass.

Applying Glue and then Sanding down

Prepare some soft rabbit skin glue and apply it to the wood in the direction of the vein. Leave it to dry completely before applying the next coat in the opposite direction. This procedure should be followed until you

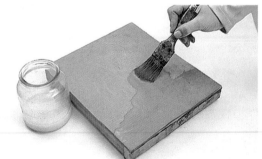

Preparing a surface with rabbit skin glue.

grade of sandpaper must also be alternated with the direction of the stroke, so use a No.1 for the first, then

MORE INFORMATION:

Attaching the wood to a stretcher **p. 26**

Other primers: latex, acrylic, and derivatives **p. 28**

ATTACHING THE WOOD TO A STRETCHER

The best rigid support is wood or, in its place, wood panels or plywood. Wood panels will save you from the unpleasant surprises that wood can present. Plywood and masonite are made up of thin layers of sized and compressed wood in crossed fibers that make it stronger than wood, which has fibers that run in the same direction, making it susceptible to splitting.

Preparing the Stretcher

Painting on wood panels means sacrificing the thickness of wood for the lightness of plywood. This reduction in thickness makes it necessary to use a stretcher to give the panel rigidity. Any standard stretcher sticks will do, or you can improvise your own. Making your own stretcher should not pose a problem, since all you have to do is cut the strips to the size you need and nail them together.

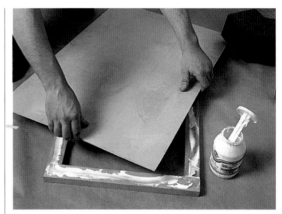

Gluing the stretcher before placing the wooden panel on top.

Gluing and Nailing

The wood is attached to the stretcher with glue and finishing nails, the stainless steel type being best in order to prevent rusting.

The wooden panel, which is larger than the stretcher, is placed on its face. The stretcher is then glued to it, making sure that total contact is made. Once it has been covered in glue, several heavy objects should be placed on top of the stretcher to obtain a uniform pressure over all the surface.

After a few hours the weight is removed and the stretcher is turned over to leave the wooden panel facing upward. The last stage consists in hammering in nails at 2″ intervals around it.

Using a Knife

Most materials are easy to cut using a matt knife. To cut the edges of laminated wood the stretcher should again be placed facing up so as not to damage the base. Then the knife is run along the edge repeatedly until the surplus piece drops off cleanly.

Cutting the sheet of plywood with a knife.

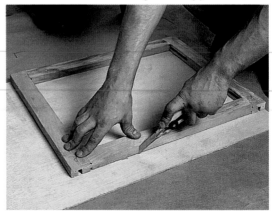

Preparing Different Surfaces: Wood, Masonite
Attaching the Wood to a Stretcher
Other Primers: Latex, Acrylic, and Derivatives

27

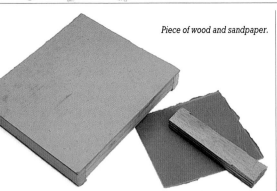

Piece of wood and sandpaper.

Painting on Wood

Painting on wood, when the surface is correctly prepared, can be done without having to rely on the texture of the surface you are painting on.

Leonardo da Vinci painted on all manner of surfaces, but his most highly regarded paintings were executed on wood. The master painted many pictures using this surface, since its rigidity enabled him to draw with ease and use a pencil or his finger to blend shadings, a technique that would have been far more difficult on canvas.

One of the most outstanding examples of his work on wood is the *Mona Lisa*.

Smoothing down the Wood

The wooden surface cannot be painted on until it has been completely sanded down. For this task you will need a block of wood about the size of a blackboard eraser and two types of sandpaper: a piece of No. 1 and No. 00.

First use the No. 1. Wrap it tightly around the piece of wood, then, without pressing down too hard, run it over the surface with small circular movements. After the entire surface has been sanded down uniformly, repeat the operation with a finer sandpaper.

The Electric Sander

The work of smoothing down wood can also be carried out using an electric sander, an instrument that always leaves the surface with a smooth and uniform surface.

The smoothing down should not be carried out until the surface is firmly attached to the stretcher. If you wish to recycle a surface that has already been painted over, simply follow the same process explained above.

Softening the Edges

It is essential to ensure that the surface is absolutely smooth and that no lumps form during the priming stage.

The edges must be sanded down with a No. 1, with the block of wood placed in an oblique position to the edge. Just a few runs are sufficient to remove any roughness.

The sanding method you use depends on the type of surface you are working on. Certain surfaces like wood

Sanding down the edges in a simple and quick operation.

panels or thick cardboard do not require sanding down, since they do not have veins or knots.

MORE INFORMATION:

Preparing different surfaces: wood, wood panels **p. 24**

Other sealers: latex, acrylic, and derivatives **p. 28**

OTHER PRIMERS:
LATEX, ACRYLIC, AND DERIVATIVES

Whether your painting surface is made of canvas, paper, or any other kind of rigid support, it has to be primed in order to prevent the fiber from which it is made (cellulose in paper and cardboard and vegetable fibers in wood) from coming into contact with the oil paint. The most traditional type of primer is rabbit skin glue, although nowadays there is a number of faster and equally effective primers, which are derivatives of vegetable resins like latex, as well as synthetic acrylic resins.

Vegetable Resins

Latex is the most important vegetable resin. It is thick and viscous in appearance and uses water as a solvent. Once it is dry, latex becomes elastic and transparent.

Latex has excellent covering powers and can be employed for both priming surfaces and in manufacturing paints.

Latex and other vegetable resins are available in art supply stores.

The surface can be primed with a brush or it can be sprayed on. If you choose the latter, make sure you apply several layers to ensure that the pores are sealed properly.

Because there are several qualities of latex, it is advisable to always buy the best product. Good quality is always the best guarantee when the moment of truth arrives.

Latex varnish.

Acrylic resins provide a quick way of priming surfaces.

The Synthetic Resins

Among the most important resins, both for priming surfaces and manufacturing paints, are the acrylic types. Synthetic resins for artistic use are available in emulsions of acrylic polymer, a product that is sold in the better art supply stores.

The excellent sealing capacity of acrylic resin makes it ideal for priming surfaces. It is applied with a brush or with a spray. It is recommendable to add some pigment or additive after the first layer has been applied.

Durability

Generally, both synthetic and vegetable resins are ex-cellent for priming surfaces for oil painting. Once they are dry, these resins become stable, elastic, and will withstand the passing of time.

It is essential that the first layers of primer be thin and more fluid than those that follow.

Relationship with the Pigment

Surfaces primed with latex or acrylic can also include pigment.

The surface can be primed using a background color, so that priming and background are completed at the same time.

In order to make the pigment workable it is necessary to add water gradually to the pigment while constantly stirring.

The mix with the resin and pigment is stirred in a circular direction; the amount of pigment will vary depending on the desired intensity. The solubility of the pigment in the resin is rapid, providing that the pigment is in liquid form.

Panel primed with latex.

Panel primed with latex and a color base.

Drying

Since both latex and acrylic are water-based products they dry through evaporation. Therefore, a correct room temperature is vital when working with this type of primer—the warmer the temperature the quicker the drying time will be. Furthermore, acrylic resin dries faster than latex.

When the resin is still wet it dissolves in water, making it easy to clean the brush by holding it under the tap and thoroughly soaking the hair. Care must

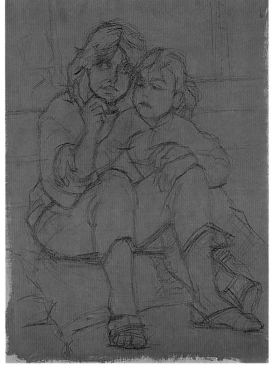

Preparatory drawing on primed wood.

be taken in order to prevent the brushes from drying, otherwise the hairs will stick together and the brush will be rendered useless.

Solvents

In the event that your brush does dry while working with latex or acrylic, a remover for cleaning brushes is available at art supply stores.

MORE INFORMATION:

Staining the canvas **p. 52**

Techniques of alternation and compatibility: fat over lean: **p. 54**

Using a Spray to Prime a Surface

The surface can be primed using a spray gun. This is an effective method for sealing the canvas, provided the latex applied is not too thick.

Cleaning the brushes.

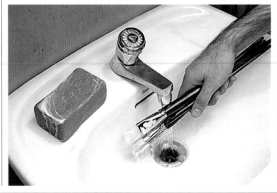

THE PAINTER'S STUDIO

The artist's studio plays a vital role in the production of his or her work.
Therefore, an atmosphere that is conducive to creativity is essential, that is to say,
the artist has to set aside a space that is to be used solely for painting.
The studio should have adequate working space, good lighting, and the necessary
furniture and tools.
It has been said that the personality of each artist is revealed by the appearance and
contents of the studio; however, some features should be very similar in all cases.

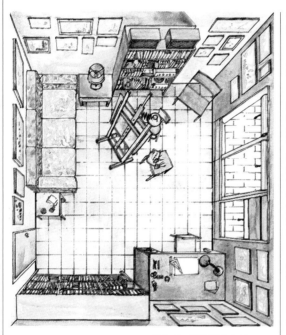

the basic furniture required in a painting studio.

Natural Light

The successful use of color in a painting depends on the source of light. When the artist paints under daylight conditions he or she should avoid direct sunlight which tends to cause reflections that distort the color relationships. On the other hand, when the artists paint by artificial light, they must make sure that no shadows are cast on the canvas.

How Much Light

By controlling the amount of light in the studio, we can obtain different moods, de-

Dimensions

Naturally, the size of the studio will determine how large one can work, that is, to be able to stand back some distance in order to get the effect of one's overall work.

One's studio should be a place set aside, exclusively, for art work. An ideal floor space would be 15 × 18 feet. The light cast on one's work should be uniformly distributed. The adjoining floor plan shows an ideal distribution of space and some of

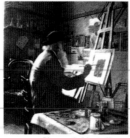

Pissarro in his studio.

MORE INFORMATION:

Other materials used in oil painting **p. 32**

Different types of easel **p. 34**

The work should receive a uniform light.

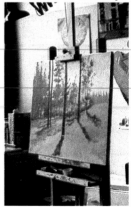

A swan-neck lamp attached to the easel distributes the light uniformly.

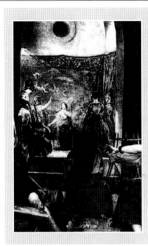

Velázquez's Studio

Velázquez's studio, known as the *workroom,* measured approximately 20 feet high by 15 feet wide and was about 30 feet long.

Such dimensions were similar to most craftsmen's studios. The studio is an excellent place in which to paint creatively. *The Spinners* was painted in this studio, as well as most of the master's portraits of dwarfs, in which he explored new techniques.

pending on whether we wish to create a hard or soft atmosphere in terms of light and shadows.

A white screen can be used as a light filter.

Artificial Light

At least three lights are needed:

• One for illuminating the picture, which should be a swan-neck lamp attached to the easel containing a 100-watt bulb.

• The second light illuminates the model. The distance between the light and the model determines the contrasts of light and shadow; the closer it is to the model, the more accentuated the contrast becomes.

• The third lamp, an auxiliary light, is to remove the sharp contrasts between light and shadow and to stop the artist from tiring the eyesight as a result of concentrating his attention on a single illuminated point.

The shadows are softened and the forms gain contour. A white screen or a curtain can be used to reduce the contrast of the shadows.

OTHER MATERIALS USED IN OIL PAINTING

A painter's studio requires more than just paints and canvas; there is a large assortment of materials and furniture that are necessary to make work easier and more comfortable. Practical accessories for the studio are chairs, stools, lamps, etc. Then there are the accessories used strictly for painting such as paintboxes, easels, paintbrushes, and jars.

Stools

You need to be comfortable in order to paint, though this does not mean using an easy chair but one designed for work, so that you can concentrate on the painting without tiring the legs or straining the back. Suitable support is therefore necessary: a tall stool or drafter's chair are ideal for painting as you can adjust the height, they take up little room, and their swivel feature enables painters to reach what they need without getting up or having to twist around.

There are many kinds of stools. The simplest and most practical ones are made from wood or metal, though there are padded and upholstered ones too. They can be bought in art material stores and office furniture shops.

Two types of stools.

Paintboxes

One of the basic accessories for painting is the paintbox. This is used not just as a handy and tidy way of keeping the oil tubes but also for holding a small canvas board attached to the lid for making sketches. Paintboxes usually have a space set aside for the palette.

A paintbox containing a palette.

A drawing table.

Paintboxes come in a wide range of sizes, from small traveling boxes with just the basic colors to the large capacity models. Their size and the materials used in their construction determine the price. Although there are many metal paintboxes with plastic compartments, the largest and most practical are the hinged top wooden models recommended for studio work.

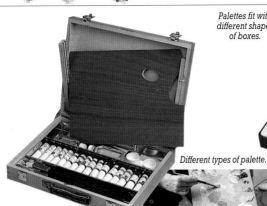

Palettes fit with different shapes of boxes.

Different types of palette.

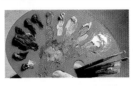

Cleaning Materials

Oils, by nature, are greasy, insoluble in water, and therefore require special effort when it comes to cleaning up. An oil paint stain is the same as a cooking oil stain, only worse in that it is colored. While the paint is fresh, it can be removed with turpentine and then soap and water.

Paintbrushes require care to keep them in good condition; during the painting session they can be cleaned in one of the two oil cups attached to the palette. If they are going to be used again soon, they are left in a receptacle that has a spring clip for holding brushes so that they do not touch the bottom.

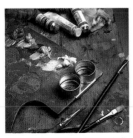

Cups of turpentine and linseed oil on the palette.

MORE INFORMATION:

Special additives: waxes, binders **p. 16**

Working with alternative materials **p. 78**

Palettes

The palette is used constantly by the painter and they exist in a wide variety of models suited to the most needs. The size depends on the range of colors used and also on the amount of paint to be mixed. It can be rectangular or oval in shape. The rectangular ones fit more easily into the paintbox.

Palettes are usually made of plastic or wood. If wood, the palette needs several coats of polyurethane varnish, sandpapering between coats to leave a smooth surface.

Paper palettes also exist, available in disposable tear-off pads for single use.

Disposable Materials

It is most important to have a variety of materials in the studio that can be put to many uses: toothpicks, small pieces of cloth, old rags, newspapers, etc. Remember that you will often need jars for cleaning or storing brushes. A galvanized metal trash can with cover is advisable because of the flammable, oil soaked, paint rags that are used daily.

Suitable Clothing

Suitable clothing is necessary for studio work.

Many artists use aprons while others choose to wear old clothing.

Frida Kalho and Her Studio

The Mexican painter Frida Kalho produced most of her work lying in bed after an accident that left her an invalid for life. She fitted her bedroom as a studio, had mirrors installed as well as a special easel for holding the paintings. From this position she was able to paint her powerful, dramatic, self-portraits.

DIFFERENT TYPES OF EASELS

Throughout the history of painting the easel has been the painters' inseparable companion and has progressively been adapted to their changing needs. Strange to say, unlike the technical developments in other fields, modern easels have not varied much from the old ones used over the centuries.
The only improvement has been the proliferation of different models, each adapted to a specific requirement.

The Right Easel for Each Occasion

There is an easel for each painting need and each type of painter. The classical studio easels are not very different to the one Leonardo da Vinci may have used. But nowadays we can choose between different models: heavy, light, with or without wheels, etc.

What we do have to consider when choosing an easel is the size of the canvas holder and the height of the upright section, particularly if we are working in a low ceilinged room.

There are other types of semi-light easels that are ideal for both studio and outdoors that are collapsible and have a built-in paintbox. For a long session of outdoor painting, it is best to take a light traveling easel that is fully collapsible and will fit in a backpack. There are also ultralight metal telescopic portable easels.

Features of a Traveling Easel

A traveling or portable easel comprises a telescopic tripod with a holder for the painting and an upright guide for adjusting the tilt. Some have adjustments for holding the palette. Such

Metal easel.

easels are stabilized by sticking the legs into the ground. They are not suited for large canvases but are perfect for making sketches.

The Studio Easel

Above all, a studio easel should be stable and movable to a certain extent. First we should decide its purpose. Do we need it to be mobile or not, does the painting need to be firmly attached or can it simply rest on the guide.

Be it a tripod or fixed base easel depends on the space available. In a small space, a collapsible easel may be more appropriate. If you have a large area to work in, one with wheels on a fixed base is much more handy and practical.

Some models allow you complete freedom to adjust the tilt thanks to a set of guide

Light studio easel.

Professional easel.

bars that move independently of the upright section.

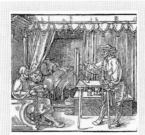

Copying

Wood-engraving of the treatise *Perspective and Proportion*. In this engraving, Dürer (1471–1528) shows us the use of another type of easel, designed to copy the model using the grid provided on the upright section.

Traveling easel.

MORE INFORMATION:

A brief history. Oil as a substitute for tempera **p. 8**

The painter's studio **p. 30**

Box-Easel

The box-easel is ideal both for studio work, where the painting does not need to be firmly held, and for comfortable outdoor painting.

It comprises a special paintbox with fitted guidebars that, when opened, form a tripod with the paint-box under the picture rest. There are several models of these easels, some with a removable drawer that is highly practical for keeping the materials you may need.

Tabletop Easel

The simplest of all models of easel is the tabletop easel. Similar to a bookrest, it is placed on the worktable with the painting on top. It does, however, limit the range of sizes you can use.

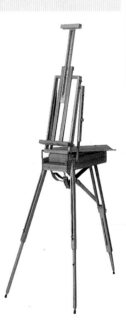

A box-easel.

The box-easel is practical and light, so it can be folded up and carried easily.

STRETCHING THE CANVAS

Before priming or painting, a canvas must be mounted on stretcher strips. Stretching canvas requires a specific technique that is applicable to all types of stretchers. There are international sizes for stretchers, although the painters do not need to confine themselves to these standard sizes as there are stretchers in non-standard sizes. You can also find circular stretchers or different thicknesses on the market.

• •

Proportions of the three standard stretcher formats.

FIGURE

LANDSCAPE

SEASCAPE

Size of Canvas and Stretcher

In Europe and many other parts of the world there are a series of standard stretcher sizes that fall into three basic formats: figure, landscape, and seascape.

The canvas can be bought ready-mounted on the stretcher or by length. The latter is always more economical and allows you to choose the type of canvas and quality of the stretcher, as well as to create any size of painting surface you wish.

Materials

Only a few, essential tools are needed to mount the canvas on the stretcher. First, you need the stretcher strips and the canvas which should be cut 1.5 inches larger than the stretcher plus the width of the stretcher. For example, if the stretcher measures 33 × 29 in. and is 1 in. thick, the canvas should be 38 × 34 in.

Materials for stretching the canvas include scissors, upholsterers pliers, staple gun, tack hammer, and flat-headed tacks.

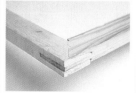

Joint of an international style stretcher.

Tools and elements for mounting a stretcher.

12

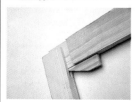

Another type of stretcher.

Staples or Nails

Traditional mounting of the canvas can use short, wide, and flat-headed tacks. This system is slow and tedious, while using a stapler is much quicker.

Also, copper staples will resist corrosion much better than nails do.

There are many types of staplers so make sure you have a good quality one. The cheaper models tend to break easily.

Stretching the Canvas

To mount the canvas on the stretcher, it should be placed face down with the stretcher centered on top and with the primed side upward.

Begin from the center of each side, then continue stapling out from each center of the stretcher strip, pulling tight with the pliers on the opposite side. Use the pliers alternately on each side to stretch the canvas, stretching any wrinkles toward the corners. Stop stapling when you are a couple of inches from each corner. You should observe the canvas continuously while you are stapling it, so the first hint of a wrinkle can be remedied before it becomes a problem.

Finishing off the Corners

Now just the corners are left. Using the pliers carefully so as not to tear the canvas, stretch one of the sides until the canvas forms a flap on the corner. This flap is folded inside and stretched over the unstapled side. Now, just stretch again to remove any wrinkles. Do the same for the remaining three corners.

Lastly, the remaining canvas is folded back over the stretcher strips and stapled.

All that is left for you to do is to hold the little pieces of protruding canvas and to carefully snip them off.

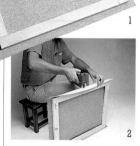

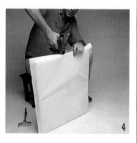

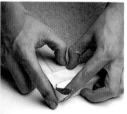

Today's Paintings and the Stretcher

Many of today's paintings need no frame when finished, therefore weak or light stretchers should not be used as they were designed at a time when all paintings were framed and thus given additional support. Unframed paintings should be structurally sound with the help of reinforcing wooden triangles screwed into the rear corners of the stretcher.

MORE INFORMATION:

Preparing the different surfaces: canvas **p. 20**

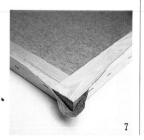

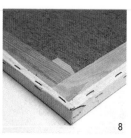

BRUSHES

The most common brushes for oil paintings are hog's hair bristles, yet there is a wide range of types and different qualities to adapt to each painter's needs. It is the quality of the brush, irrespective of its shape and purpose, which determines its effectiveness. The price is determined by the quality, but that does not mean more economical brushes cannot be used. It's simply a matter of knowing when and how to use them.

Brushes for Oil Painting, Types and Qualities

The brush comprises the handle, ferrule, and hairs. The ferrule is the metallic band that grips the hairs. The handle for oil brushes is longer in order to enable the painter to hold it toward the end and work at a greater distance from the painting with the arm almost outstretched. The size of the brush is shown by the number printed on the handle. Sizes range from 1 to 20.

Brushes may be made from hog's bristle, sable or badger hair, or synthetic hairs; each of these comes in three shapes:
• Round brushes.
• Flat brushes.
• Fan brushes.

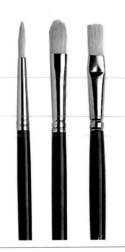

High Quality Brushes

Sable and badger hair brushes are of high quality. Their main feature is the softness of the hair and the clean stroke it provides.

All brushes should be kept clean, but this applies even more so to sable hair brushes for two reasons: the first is the cost, and the second is that old but well-cared-for brushes perform better than when new.

Synthetic Brushes

There is a wide variety of high quality synthetic hair brushes to choose from. Even though they last a long time, they should be treated with the same care you would give a sable hair brush. Remember that they easily deform if they are left in water on their tip.

Economical Brushes

Scholastic grade brushes are also available everywhere. This quality is usually

Quality brushes are flexible and regain their original shape.

quite limited and eventually sheds its hair. Before using brushes for the first time, it is advisable to leave them to soak in water for 24 hours to expand the wood so that it grips the ferrule more firmly. Take care that the hairs do not touch the bottom; try attaching the handles to the mouth of the jar with an elastic band.

The variety of brushes most commonly used by a professional could be the following:
• A round brush, sable hair, no.4.
• A flat brush, hog's hair, no.4.
• A round brush, synthetic, no.6.
• Two flat badger hair, no.6.
• A cat's tongue brush, hog's hair, no.6.
• Three flat brushes, hog's hair, no.8.
• Two flat brushes, hog's hair, no.12.
• One cat's tongue brush, hog's hair, no.14.
• One flat brush, hog's hair, no.20.

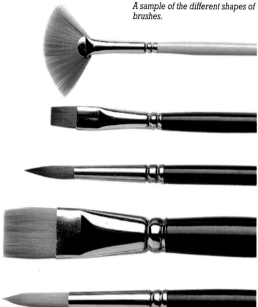

A sample of the different shapes of brushes.

Quality Brushes

In these times of mass production, it is unusual to find handmade articles for professional use as they have often been replaced by machine production.

High quality brushes still need to be handmade. The choice and position of the hair inside the ferrule is a task that cannot as yet be done industrially.

Medium Quality Brushes

The type most commonly used by artists is medium quality hog's hair brushes. There are some that are almost in the category of high quality brushes, with soft flexible hairs and with somewhat similar features to sable hair brushes.

There is a wide range of hog's hair brushes. The high quality ones are excellent for painting softly, and executing color blends.

The hog's hair is the artist's preferred brush, since it is relatively cheap and durable. However, there are a number of high quality hog's hair brushes that can be alternated with sable hair brushes.

It is important to bear in mind that not all painters demand high quality brushes; it all depends on the type of work you wish to do.

MORE INFORMATION:

Maintenance and cleaning of brushes **p. 40**

Applications of the different brushes **p. 60**

A range of medium quality hog's hair brushes.

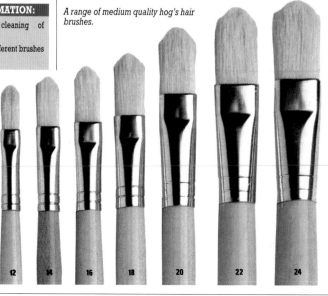

6 8 10 12 14 16 18 20 22 24

MAINTENANCE AND CLEANING OF BRUSHES: CONTAINERS FOR CLEANING

The brush is undoubtedly the artist's most important piece of equipment and must always be kept in excellent condition. It may often seem tedious to have to devote time to cleaning your painting materials, but bear in mind that if it is not done properly they can dry out, become damaged, and require replacing.

Cleaning Materials

So that your painting materials are always ready for use, a few simple everyday items should be at hand, such as newspaper, old cotton rags, and jars for the brushes.

Cleaning is a constant process while painting, especially if you often change color. Usually it is enough to clean the brush with a piece of newspaper, dip it in turpentine, and squeeze it out on the paint rag.

For maintaining and cleaning brushes, soap (neutral if possible), water, and flat recipients (such as plates or trays) are the most commonly used.

Pure Turpentine

Turpentine is available in many forms. Which you choose is not important, but make sure the label describes it as "Pure Gum Turpentine."

Turpentine is available in small 2½ oz. bottles or in quarts and gallons. Essence of turpentine is

Turpentine.

extracted directly from pine trees and is a natural solvent of oil.

An Emergency Solution

When you are working on a painting, it can be tiresome having to clean all the brushes just to resume work a few hours later. Brushes can be kept away from the air if cleaned

An emergency solution.

with newspaper and placed under water on a bowl so that the hairs are not bent or matted. You can keep them this way for up to three days. For longer periods it is advisable to clean them, as both the wood and the hair can start to deteriorate. Turpentine substitutes, on the other hand, may very well dissolve the oil but at the same time damage the hair of the brush to the point of destroying it completely.

Rags and papers are essential for painting.

The Container for Cleaning Brushes

A brush cleaning container is a very simple piece of equipment you can find in art stores. At the top it has a spring onto which the brushes are hooked so they are suspended without the hairs touching the bottom. When the container is full of pure turpentine, the oil from the brushes slowly dissolves and, being heavier than turpentine, sinks to the bottom. This way you always have some relatively clean turpentine available for further cleaning sessions.

This container is most useful when working continuously on a painting; a much better method than immersing the brushes in water. First, because the brush is submerged in a like medium to oils, and second, because the oils are totally dissolved and the brush is left completely clean and ready for the next session.

A container for cleaning brushes.

Care of Your Brushes

The traditional method of cleaning brushes is with soap and water. The brush hairs are rubbed on the wet soap in circles, wetting it now and then to remove the dirty foam. When most of the foam has been removed, the brush is rubbed on the palm of the hand until completely clean and white. Last, it is rinsed thoroughly until all the soap is gone. The hairs are then reshaped and the brush is left to dry in a jar with the hairs upward.

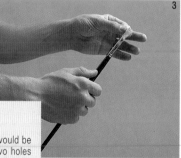

Cleaning the brush.

1

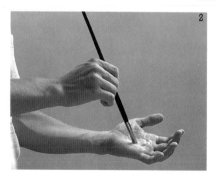

2

Rubbing the brush.

3

Straightening the hair.

A Brush Cleaner

A makeshift container would be an empty can. Make two holes on the top, one opposite the other, to hold a double elastic band or piece of spiral wire from a notebook. Make holes on the lid of the can to act as a false bottom and place small screws as stops.

MORE INFORMATION:

The composition of oil. Resins and pigments **p. 10**

Grinding oil **p. 12**

PALETTE KNIVES

Palette knives and brushes are essential tools for oil painting. Everyone knows what a brush can do, but not many are familiar with the possibilities of the palette knife, a tool that every painter is required to master if he or she is to exploit the oil medium to the maximum. Palette knives come in various shapes and sizes, the most common of which look like a trowel and are used in a multitude of ways.

What the Palette Knife Can Do

Palette knives, flexible tools generally made of steel and shaped for specific purposes, can be used in several ways in oil painting: for cleaning and rectifying errors, for painting and applying impastos, and for spreading the paint over the canvas. In addition, one the most basic uses of the palette knife is to remove paint from the canvas.

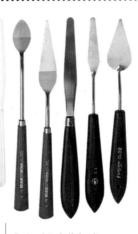

Each palette knife has its own specific purpose.

Mixing Color

Solvents are not used when you work with the palette knife. The paint is applied as it comes from the tube, thick. The palette knife is used both for mixing and applying paint. In general, artists tend to work with two or three types of palette knife, each of which is used for a specific task.

1 and 2. To load paint from the palette, you have to hold the knife at an angle, cutting and separating the amount you require.
3. A quantity of paint is spread over the palette.
4. The process is repeated

Mixing color with a palette knife.

with the other color, which is then left on top of the first one.
5 and 6. Finally the two are mixed until the desired tone is obtained.

Looking After Your Palette Knives

It is important to take care of your palette knives. All you need is some newspaper

and turpentine to keep them in good clean condition. If you do not plan to use them for some time, soak them in pure oil and wrap them up in newspaper.

Painting with the Palette Knife

Once you have mixed the paint on the spatula, scoop the amount you want with the edge of the palette knife and apply it to the canvas. This method can be used for creating edges, outlining, and drawing.

You can also use the palette knife to superimpose one color on another, with the possibility of creating multicolor areas, gradations, and an infinite variety of textures.

Painting with the Palette Knife over Paint Applied with a Brush

There are two ways of employing the palette knife; the first consists of working on a layer of paint applied with a brush. It is important therefore that the initial color be applied in a liquid form, that is, it has to be diluted with a generous amount of turpentine so that it does not form a thick layer. The palette knife can then be used to apply and/or mix colors directly on the canvas.

It is advisable to work on the larger areas first, leaving the smaller ones for future sessions.

Direct Painting with a Palette Knife

You can also use the palette knife to paint directly on the canvas, but this is far more difficult than applying color over a thin layer of paint, since the background colors help to re-

Applying paint with a palette knife.

solve those areas that the palette knife cannot reach.

The general colors of the largest areas have to be painted, taking care to not go over them in later sessions.

Details and smaller areas require more intricate work, with thin layers of paint that can be applied in successive phases. In these areas it is advisable to mix the paint on the palette.

Touching up with the Brush

You will enjoy working with the palette knife. This tool gives the painter the opportu-

The Palette Knife in History

The palette knife was preceded by the bronze *cestra* tool used in encaustic painting, which required paint made from pigment mixed with melted beeswax and resin, and application fixed by heat.

nity to create very interesting plastic effects; a technique that permits touching up with other instruments like the brush or the tip of its handle.

However, use sable hair brushes for touching up flat

areas worked with the palette knife, because their characteristic soft stroke will not alter what you have done.

The Tip of the Palette Knife

The trowel-shaped palette knife is distinguished by its

shape and hardness. The longer, more flexible palette knives are ideal for painting, rectifying, and erasing. The hardest knife is specially designed for scraping away dry paint and for even cleaning the palette.

MORE INFORMATION:

The palette knife, applications **p. 56**

The palette knife as a complement to the brush **p. 58**

Textures **p. 74**

Additives to create texture in oils **p. 76**

GREAT THEMES: STILL LIFE, PORTRAIT, LANDSCAPE

Throughout the history of painting, the oil medium has been used to capture what is commonly known as the "great painting themes."
It was during the Renaissance that Flemish painters attempted to interpret their subjects with the greatest possible realism. It is thanks to artists of the caliber of Van Eyck that the great themes, the portrait, the still life, and the landscape, are still painted with the same enthusiasm to this day.

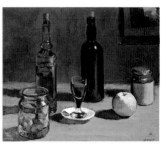

A landscape in which depth is of fundamental importance.

The brilliance and hues are evident in this still life.

The Possibilities of Oil in the Theme

Oil can be adapted to any of the existing styles, from the most meticulous techniques, rich in detail and almost photographic, to the most expressionist of themes, in which emotional forces dominate the subject matter. Oil is the most versatile of all painting mediums. Its elasticity, richness, transparency or opaqueness (depending on what the artist requires) gives oil the greatest creative and plastic potential.

Portraits can be executed with conventional flesh colors or with chiaroscuro and textures.

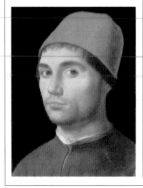

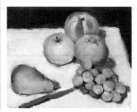

Theme and Composition

Unlike other pictorial techniques, oil can undergo a series of constant changes from the start to the finish of a painting if the artist wishes.

Given the great variety of technical possibilities that the oil medium has to offer, each artist can develop his or her own style. The theme, as well as the way in which a composition is arranged, will also influence the technique. The composition of a picture consists of arranging the elements of the subject matter within the space designed for it.

Three studies of composition, two of which are incorrect; the first is unoriginal and monotonous, whereas the objects in the second are too dispersed. The third one is correct: here there is unity due to the arrangement of the elements.

Joris Van Soon, Still Life

The Still Life

The still life provides the painter with the chance to study the subjects of light and composition in a more in-depth manner. A still life can be painted virtually anywhere, since the objects required are all around us. The composition is obtained by laying out various objects on a table. Objects as common as containers, books, shoes, etc., are ideal elements for a still life. The elements are arranged according to the type of composition and light you want in the painting.

As its name suggests, the still life painting represents inanimate objects like those mentioned above. Other examples of objects for a still life painting include game, fruit, flowers, etc.

The Portrait

The portrait is one of the most important genres, since it was through this theme that the main technical and creative advances in oil were made. The versatility of oil, with its glazes, impastos,

The First Still Life

The still life came into existence around the year 1596. Before then, this theme was used as an element in religious themes or heroic or mythological scenes.

It was Michelangelo Merisi, known by the name of his home village, Caravaggio, who was first said to have arranged some fruit in a basket to paint. From that time to the present day, still life did not have to exist as a filler or a complement in other genres, but as a fully independent entity, ideal for studying light, composition, and texture.

subtle gradations, has permitted many new styles. In addition, oil enables parts of a painting to be changed or retouched, making it the portrait medium *par excellence*.

The Self-Portrait

The most significant variant of the portrait is the self-portrait. From the very beginning the portrait has been used as a pretext for testing out new ideas. Most artists paint their own portrait at least once. Little is needed to paint a self-portrait: the basic setup consists of a mirror and, as a model, yourself. By painting one's self-portraits a number of times, the artist becomes more familiar with facial features and learns to understand color and flesh tones under different lighting conditions.

The Landscape

The use of oil in landscape allows the artist to employ a

Vincent Van Gogh
The Postman Roulin

number of techniques, as well as to make changes at any point. The landscape in oils can be executed with broad sweeping strokes in order to represent the most important forms, which can then be defined as the painting progresses.

Hans Hemiling,
Vase of Flowers in a Niche

Camille Pissarro,
Self-Portrait

Paul Cézanne,
Self-Portrait

MORE INFORMATION:

The background-figure relationship **p. 70**

How to use backgrounds **p. 72**

Highlights of flesh colors **p. 80**

TECHNIQUE: SKETCHES, FAST COLOR NOTES

One of the most interesting aspects of the oil medium is the fact that it can be used to seize something in a spontaneous manner while capturing the character of the subject. Evidence of this can be seen in numerous masterpieces by artists such as Rembrandt, Goya, Van Gogh, etc., executed with spontaneous brushwork. Loose painting in oil can be employed with all genres, but mastering this technique requires much perseverance.

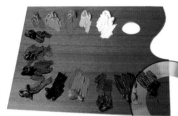

Preparation

The fast strokes must concentrate on the most basic elements. Both the preliminary sketch and the fast strokes should avoid excessive detail. They are generally used as color notes or for trying out different compositions for a specific picture. All you need for executing sketches is some thick paper or small pieces of cardboard, a few colors (not a wide range), as well as the usual array of cleaning items: paper towels, cloths, turpentine.

The Preliminary Note

An area painted in oil has to include a concise outline of the form as well as to define the color. The forms can be done in sanguine, charcoal, or even oil paint thinned with turpentine. But the importance of the drawing should never be underestimated. Much practice is required to become proficient in drawing. The free application of paint can also be defined as draw-painting, that is, building up the definitive forms of a painting by means of loose strokes. Correct understanding of volumes through large areas of color requires not to get bogged down in details.

Small Works

Both sketches and color notes are normally executed on small surfaces and, depending on the theme the artist is going to paint, contain a greater or lesser amount of turpentine. When painting rapidly, the artist does not execute one single picture but a series of color notes, which helps the artist to appraise the theme and to anticipate any potential problems. It is for this reason that the resulting color sketches do not generally have a finished look.

A small note painted on cardboard.

The fast color note need not be painted with many colors; red, yellow, blue, and white are sufficient to obtain the approximate colors of nature.

Synthesis of painting alla prima *powerfully captures form and light.*

The *Alla Prima* Technique

The technique of *alla prima*, roughly translated as "at the first try," should not be confused with sketching, even though it is a similar technique. To be able to paint *alla prima*, the artist must acquire the ability to see the subject as a whole. In other words, this technique entails capturing the basic form and color of the image. The artist applies paint to the canvas with the aim of obtaining the elementary images. Then he reexamines the composition in order to build up detail over his initial impression.

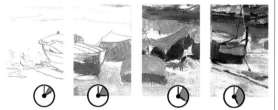

A picture alla prima *painted over a period of four hours.*

Goya and Direct Painting

Goya's agile style is immortalized in the numerous paintings he executed in the direct painting technique. In these highly personal works, the great artist froze the scenes he saw, rather as a photographer does with his camera. The complete mastery of the drawing and fast painting were Goya's two most important tools.

Goya, *Two Strangers* **(detail)**

Fast Roughing-Out

It normally takes one session to direct-paint a picture, executed with spontaneous free brushwork.

First do a fast sketch of the subject. Do not concern yourself with details; leave it "open" so that modifications can be done later. Once the sketch is finished, paint the entire surface of the canvas with the approximate colors, applying large strokes to cover all areas. When the canvas has been roughed out, it is possible to establish highlights, shadows, and to emphasize forms.

All that remains is to create some tones and tidy up the stains, but without attempting to add details.

Rapid and covering brushwork.

Oil and Brush Drawing

In direct painting, the wide brushstrokes do not allow for details. All forms should be thought of as masses, although you can add some detail during the final stages. This lack of detail compels the artist to make use of the brush in developing shape and volume. In this way it is

possible to delineate the theme with paint and simplify the forms to the maximum. This particular brushstroke skill is clearly seen on the canvas, it reflects the character of the artist and the intended shape.

The stroke follows the form.

| MORE INFORMATION: |

Roughing-out the canvas **p. 52**

Techniques of alternation and compatibility **p. 54**

Use of the different types of brushes **p. 60**

Alla prima painting **p. 64**

COLORS MIXES

Mixing colors enables the artist to obtain a wider color range. One of the reasons why oil is considered to be the most versatile of mediums lies in the fact that the number of gradations obtained from it are almost limitless. But, in order to master the art of color mixing, it is essential to understand some elementary notions, such as knowing how to arrange your colors on a palette and how colors are related to one another.

Mixing and Color Theory

When Newton carried out his celebrated experiment of beaming a ray of light through a glass prism, he observed how the white light was broken down in a spectrum of colors: dark blue, light blue, green, yellow, red, and purple. Later on, Young was to discover that the six colors of the spectrum could be reduced to three basic or primary colors: red, green, and dark blue. By superimposing the lights of three lanterns he obtained the remaining colors: with the red and the green lights he obtained yellow, with the red and the dark blue he had purple, and light blue was seen by mixing dark blue and green lights. These colors are known as secondary colors.

When a pigment color receives light, it absorbs only those colors of the spectrum that belong to it, so we only see that part of the spectrum that is reflected.

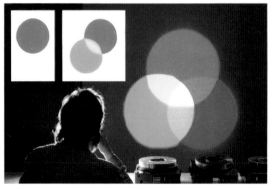

The mixing of colors.

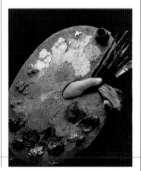

Arranging the Colors on the Palette

Oil colors should be arranged on the palette in a logical manner. The way in which they are arranged depends on the chromatic range we are using, but the one shown here is completely valid for obtaining a rich and complete color range. The hues of a color should be placed in a descending order of tone or luminosity. The way in which you arrange your colors depends on yourself, although it is simpler for the beginner to situate the colors in as simple a way as possible.

Mixing Colors

To mix colors on the palette, we have to know some-

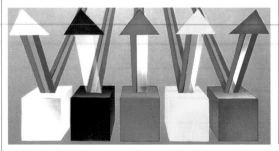

All objects reflect the light they cannot absorb.

thing about how colors are formed: what the primary ones (P) are, how the secondary colors (S) are obtained by mixing the primaries together, and how, if we mix the secondary colors together, we obtain the tertiary colors (T). Once you understand how colors behave when they are mixed together, it is possible to carry out an almost limitless number of mixes. The search for a specific color is carried out on the palette by loading it with a small amount of the paint and adding an appropriate second color to it in order to obtain the desired result.

Color Mixing on the Canvas

Some artists are color purists and like to apply paint

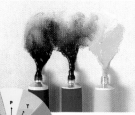

Mixing of color pigments.

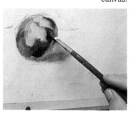

How colors are mixed on the canvas.

directly on the canvas right out of the tube; others prefer to mix on the palette and then bring out the definitive color by blending it with the colors that have been previously applied to the canvas. It is essential to understand color theory in order to master the art of mixing colors, since some colors muddy others. It is important to remember which colors dry more quickly, and to bear in mind the "fat over lean" maxim, which states that a slow-drying color applied under a fast-drying color will make the top coat crack.

Qualities of Oil Paints and their Mixes

A palette is something truly personal, to such a degree

that it is sometimes possible to identify the painter simply by looking at his or her choice of colors. It is for this reason that certain colors are extremely difficult to obtain when you try to copy the work of another artist. Good artists are always experimenting with color; they do not always use a specific brand. Therefore the professional's colors often contain both expensive tubes of high intensity colors and cheaper brands that, when mixed together, produce that personal touch.

The Palette Knife as a Mixing Instrument

Mixes carried out on the palette can be done with either a brush or a palette knife; the latter allows the user to load more paint and waste less, since you can take full advantage of the paint on a palette knife and a knife is easier to clean than a brush.

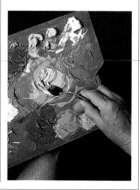

THE PALETTE

When artists start to paint a picture, they will always opt for one specific color range, one with a tendency toward the atmospheric chromatism that needs to be transmitted to the painting or even the light that envelops the model represented. The choice of color range is normally chosen before painting starts in earnest. The colors they are going to use are arranged on the palette so as to avoid confusion with other colors. There are three basic color ranges: warm colors, cool colors, and neutral colors.

Different Types of Palettes

There is an appropriate type of palette for each chromatic range, depending on whether it is of a warm or cool tendency. It is generally easy to tell what the chromatic range of the subject is, that is to say, the predominating color, which will tend to be either warm or cool. However, sometimes the tendency is determined by the artist's aesthetic interest. For instance, a seascape whose predominating color is blue, could be painted in a totally warm tone, provided that the tone is as intense as the actual color of the subject.

Color Arrangement

The colors should be arranged in a logical manner on the palette. Since the artist is forever mixing the hues with one another, the way in which the colors are arranged is important: if there are several tones within a certain range, it is more convenient to arrange them according to their tonal gradation. This will facilitate color usage and help differentiate their chromatism by proximity.

Many painters prefer to place the cool colors on one half of the palette and the warm ones on the other side.

Color Harmony

The search for harmony among the different chromatic ranges is a truly complex art. What we mean by harmony here is the optimum relationship between colors and their tonalities. There are diverse harmonic color ranges, which enable us to paint within a cool, warm, or

Degas, Portrait of a Woman, *a picture executed in the cool range of colors.*

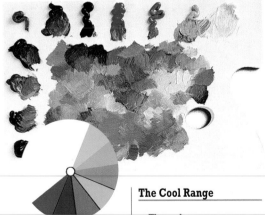

broken color range, and within each range there exists a harmonic relationship among the colors. In this painting by Degas note the subtle color harmony with a cool tendency.

The Cool Range

The color ranges are established according to their "temperature." Thus, those colors that approximate blue on the tonal scale are said to be of a cool tendency. The cool range consists of those colors and tones that are either totally or partially blue

in tendency. In no way does this imply that red cannot be included.

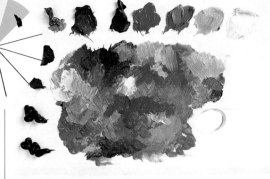

The Warm Range

In practice, the warm range comprises all those colors that are related to the color red, including the wide range of earth colors. Although colors like cobalt blue and Prussian blue do not correspond to this range, there is no reason why they could not be employed in a painting with a warm direction, since they are ideal colors for painting shadows or dirtying certain tones.

Within the so-called *cool* ranges, it is possible to find warm tendencies, such as yellow green or violet. And even the coolest color can take on a warmish tendency if mixed properly.

Rembrandt's Palette

Even though Rembrandt's warm palette contained very few cool colors, the master did use them to tone down or reduce warmth from those tones that appeared too temperate, such as the brown and ochre colors, thus obtaining subtle transitions from a warm harmony to a cool one.

Rembrandt, Holy Family *(detail)*.

Working on the Palette

It takes much practice to be able to use a palette with confidence. Mastering the art of color mixes takes time and dedication; therefore, you should spend as much time as possible mixing colors on the palette and comparing them to the colors you are searching for. If you are persistent enough, you will eventually be able to obtain the desired color.

The Broken Range

Broken colors are obtained by mixing complementary colors together in unequal parts and then adding white

to the result. For instance, if we mix a small amount of intense red with green, we obtain a khaki tone, which will appear greener the lesser amount of red we add to it. If we then add some white, we obtain a grayish color. Broken colors may take on either a warm or a cool direction.

MORE INFORMATION:

Other materials used in oil painting **p. 32**

Color mixes **p. 48**

Roughing-out the canvas **p. 52**

Blending colors **p. 62**

ROUGHING-OUT THE CANVAS

The painter needs three basic requisites to paint: light, materials, and the know-how. In addition, the artist has to follow certain guidelines, since the execution of a picture is a gradual process and, even though oil paint can be constantly modified, if we start with a clear objective and the correct technique, the painting will develop with greater fluidity. The study of the composition, the structure of the picture, and the application of paint to the canvas form the framework of the painting.

Structure and Composition

Once the subject has been studied, we have to determine the placement on the canvas in order to arrive at the balanced composition. The painting's structure is formed by the subject's most significant lines. The outlines of the subject can be drawn with charcoal or even with oil paint thinned with turpentine. This type of study establishes how much space each one of the elements will occupy and determines the limits of the different masses.

The Main Masses

The technique of roughing-out the canvas with large sweeping strokes sets down the subject's most important volumes. One way of understanding this is to observe your subject through squinted eyes. This enables you to make out only the most significant masses of color. We have to apply those masses to the canvas, having first looked for an approximate color to begin with, in large approximate lines, filling in the areas with color.

The scheme shows the composition's most important lines.

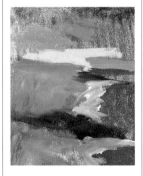

The roughing-out of the painting helps define the planes.

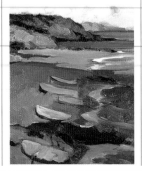

The Chosen Range

From the very start, the subject provides us with a color range to follow. Observe the type of light that bathes the subject, because it is a clue that will aid you in deciding what color range to use. The painter must control the painting at all times. Even if the subject has a warm tendency, we can paint it in a cool range of colors, playing more with the tonal scale rather than the specific color chosen.

Each harmonic range can be employed in opposing colors.

Brushes

The first stages of the painting need to be executed quickly; therefore, you need to paint with wide brushes, which hold more paint than smaller ones. The work of roughing-out always requires later refinements, and it is in this second stage that you start to alternate between different brushes. The roughing-out develops the forms that will later on be further defined by way of toning, and the inclusion of shadows, volume, etc.

MORE INFORMATION:

The palette **p. 50**

The palette knife as a complement to the brush **p. 58**

Applications of different types of brush **p. 60**

Painting *alla prima* **p. 64**

The Performance of the Brushstroke and Oil Paint

The general roughing-out is important, since it enables the artist to establish the general forms of the subject on the canvas. The brushstroke as such creates flat forms. What a brushstroke can do depends to a certain extent on how much paint has been loaded on it. Generally, at this stage, it is not advisable to work with paint direct from the tube. It should be first thinned down somewhat, so as to not concentrate the paint in an area that will later on have to be reworked.

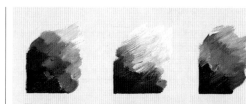

The Roughing-out and Development of the Picture

The initial roughing-out of the canvas is essential for the correct development of a painting. The dominant color you choose from the start should determine the color range you are going to work with throughout the rest of the painting. Rather than concentrate on detail, you should focus on the precise color range you want the picture to acquire.

Linseed Oil and Turpentine

Roughing-out brushwork must be applied thinly. All oil paint is thick because of the linseed oil it contains. Products such as turpentine (a thin oil derived from pine) makes linseed oil more soluble, thus losing its viscosity. Therefore, you should first soak your brush in turpentine before loading any paint from the palette.

It is not essential to use large amounts of paint to rough-out the canvas; a thinly applied wash is enough.

The staining of the canvas will be thinner than later layers of paint.

ALTERNATIVE AND COMPATIBLE TECHNIQUES: THICK OVER THIN

Oil has a glossy and brilliant finish. Whether it be linseed oil, poppy oil, or walnut oil, thanks to its transparency, the oil impregnates and mixes with the pigment, lending it color depth and stability after it has dried. A layer of oil needs a few days to acquire bite (meaning the paint is dry to the touch). If the layer is painted over a thick layer, the elasticity of both come into conflict and cracks are produced on the surface of the painting. The proper approach is to apply a thin first coat.

Characteristics and Properties of Oil

Understanding the oil medium is the first step toward utilizing its full potential with a certain guarantee of results. Oil possesses a series of characteristics that make it unique with respect to other mediums: color stability after drying, limitless colors, elasticity, and volume. The artist can paint in the style of other pictorial techniques: matte or glossy like tempera, but always with the opportunity of making changes thanks to its slow drying time. Oil can be worked transparently like watercolor; it can be textured or applied completely smooth, while remaining stable even in the case of thick impastos.

Thin Roughing-out

We know that oil paint is a thick medium, and that the base has to be thinned. Thus, we can resort to a thin roughing-out. Painting thinly, that is, reducing the proportion of oil from 50% to 30% and leaving around 70% turpen-

A picture painted with acrylic paint is a good foundation for an oil painting.

tine (these are approximate amounts), will allow you to obtain optimum results.

Another option is to apply a completely lean layer in latex. Such a lean and watery technique allows for rapid drying, which notably speeds up the process and enables the artist to apply oil soon afterwards.

Alternative Mediums

Knowledge of other mediums provides the artist with greater flexibility. Oil is compatible with practically every other non-water-based medium, as long as the painter knows how far he can go with it. Used sparingly, wax crayons, warmed in a water bath, can be mixed with turpentine and oil in order to produce a satiny quality.

Pastel and Crayons with Oil Paint

There are a number of ready-made products on the market with an oil base that can be used in conjunction with oil paint. Pastels and

Interesting effects are obtained by alternating techniques.

MORE INFORMATION:

Additives to create textures in oils, p. 76

Working with different materials, p. 78

A Painting with Texture

Note how the texture stands out on this work. The thick brushwork and impastos cover a flat underpainting. This technique is possible because the lower layers of paint are thinner than the uppermost ones. This prevents the final heavy layers from cracking.

wax crayons in stick form can be used. These are soluble in oil and turpentine and are excellent for executing color sketches prior to starting the painting, and before brushes come into play.

Adding Materials

One of the most interesting possibilities of oil painting is its capacity to hold and retain different materials. Without doubt, this aspect allows the inclusion of a diverse range of materials that can be used for creating different textures. You can add a little sand, powdered marble, etc., to the oil on your palette. Once it has dried, the oil will have encased the material added, which will then enhance the texture of the picture.

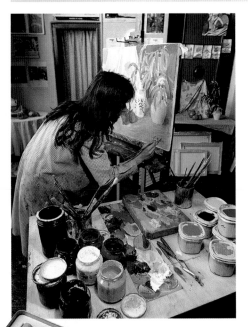

Many painters employ several techniques in a single picture, taking care to never paint thin over thick. The artist here is applying oil over acrylic.

There is immediate interaction between oil pastels and thick mediums.

Pastel dissolves in oil and in turpentine.

THE PALETTE KNIFE, APPLICATIONS

The palette knife is indispensable in oil painting. Employed both for mixing and for applying the paint, the palette knife did not come into use until the nineteenth century. Since then this essential tool has been applied by abstract and figurative painters alike. The palette knife is especially apt for use with oil paint, which, thanks to its thick and creamy nature, can be modeled on the canvas.

The painter can use the palette knife to fill in open spaces on the canvas.

The Impasto

There are various ways of executing impastos.

• The sketchy basic stages are applied with an elongated palette knife, without any need to create texture. The paint is loaded on the reverse side of the knife and is then spread over the canvas to create the masses and volumes of the subject.

• Thick impastos are done with the palette knife to create all sorts of textures. The characteristic way of applying impastos is to load the knife with paint and then to "leave" as much paint as possible on the canvas. Then, use the palette knife to model and shape the textures.

Impastos are always applied from thin to thick, that is to say, the first layers should contain more turpentine than the last ones.

Brushwork facilitates the work with a palette knife.

MORE INFORMATION:

Palette knives **p. 42**
The palette knife as a complement to the brush **p. 58**

The tip of the palette knife is used to model the texture of the oil.

Spreading the paint gently across the surface creates mottled streaks of color.

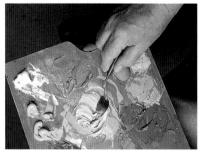
Mixing color.

Painting lines with the edge of the palette knife.

Pentimento

The work with the palette is distinguished by the evident texture that it leaves and by the way it blends in with the lower layers of color. The palette knife is an excellent instrument for correcting areas, whether they have been executed with a brush or with a palette knife. While the paint is still fresh, the corner of the knife can be used to quickly and cleanly scrape up the area that is to be changed.

Working with the Tip

Having already roughed-out the canvas, with the tip of the knife it is possible to create:
• *Sgraffito* (scratching into the lower layers of color).
• *Grainy effect* (repeatedly sticking the palette knife to the canvas and then unsticking it).
• *Pointillism* (leaving tiny daubs of adjoining color on the canvas that, seen from a distance, give the impression of a chromatic unity).

Mixing of the Painting

Loose "brushwork" can be obtained with the palette knife by applying colors directly onto the surface and spreading them them over the canvas so that the different colors are incorporated.

Direct mixes create bright fresh colors; in fact, many painters prefer to work solely with the palette knife.

The Flat Palette Knife

The palette knife has many uses. With the flat side textures are created, similar to the way a bricklayer uses a trowel. It is possible to obtain totally smooth surfaces by lightly running the palette knife over the surface. A streaky mottled effect can be obtained with the flat palette knife by applying one color over another.

Creating sgraffito *on freshly applied oil paint.*

Executing flat strokes in order to create a uniform area.

The Potential of the Palette Knife

Every possible palette knife technique has been used in this painting, combining the impasto, the streaky, mottled effect, and direct mixes on the canvas. The palette knife is especially useful for creating geometric forms.

THE PALETTE KNIFE AS A COMPLEMENT TO THE BRUSH

The execution of a painting requires sound knowledge of brush and palette techniques. Painting in oil gives the artist the opportunity to combine these two techniques in a single work and perfectly integrate the wide range of effects they can create. In fact, the combination of these two tools is one of the most common practices in the "trade."

The general roughing-out of the canvas.

Here, the palette knife was not used for the roughing-out.

Alternating the Palette Knife and the Brush

The roughing-out session can be carried out with a palette knife or a brush. The palette knife is perfect for resolving the picture's planes and synthesizing its forms. The brush is ideal for filling in spaces, unifying and creating complex forms.

If we begin by roughing-out with a brush, we can use the palette knife later in those areas that require texture. For instance, the forms of a landscape can be painted with a brush, and then the sky can be reworked by adding a new color with the palette knife to create streaks or clouds.

On the other hand, a fast painting session with a palette knife can be alternated with a brush, since the softness of the brush complements the boldness of the knife.

The Brushstroke and Touching up with a Palette Knife

Once the canvas has been covered, the artist can choose whether to continue using the palette knife as a unifying element in certain areas, or superimposing impastos.

The palette knife can be used in as many ways as the brush; each one leaves its characteristic mark. Making changes with the palette knife, when the work is carried out entirely with the brush, has to be done in a way so that the rhythm of the brushwork remains intact. Only load small amounts of paint onto the palette knife, and apply it in the same direction as the brushstroke in order to blend the color evenly together.

The palette knife can be used to stain the canvas once it has first been gone over with a brush.

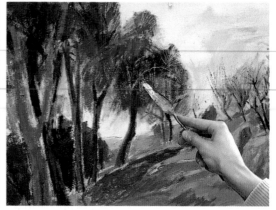

The Palette Knife, Applications
The Palette Knife as a Complement to the Brush
Applications of Different Types of Brushes
59

The Palette Knife for Roughing-out and the Brush for Defining

The palette knife can be used to resolve quickly the painting's color masses and to fill in large areas without leaving a texture.

The brush can then be used over the freshly applied paint to define the forms and add new colors.

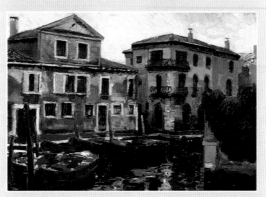

A work painted by alternating the brush with the palette knife.

Filling in Large Areas

When necessary, the palette knife, loaded with paint, can be used to cover the entire surface of the canvas with paint, in which case a wide scraper knife works best because it is ideal for spreading the color evenly. Then you can begin working with the brush.

Textures Obtained with the Palette Knife

Each painting instrument leaves its own particular mark on the canvas.

In the case of the palette knife, the stroke forms part of the texture and a group of strokes can construct the entire picture.

Here are just a few of the possible strokes that can be obtained with the palette knife:

• *Long stroke* with a tail.

In the development of a painting, the brush is alternated with the palette knife until the desired effect is obtained.

• *Short and concise strokes,* releasing all the paint in a specific area.

• *Daubs,* leaving tiny points of paint in a specific area.

• *Descriptive strokes,* providing form and volume to the painting.

The brush is used to reshape the paint applied with the palette knife.

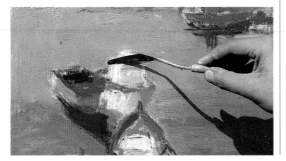

Spreading the paint with the flat side of the palette knife leaves a trail of paint.

MORE INFORMATION:

Palette knives **p. 42**

The palette knife **p. 56**

Painting *alla prima* **p. 64**

APPLICATIONS OF DIFFERENT TYPES OF BRUSHES

The painter's tools are the palette and the brushes. Colors are mixed in order to obtain particular harmonic ranges, for which each brush has a distinct purpose. Some brushes are extremely soft and fine while others have thick, stiff hairs; red sable brushes, flat, round, or fan-shaped brushes, some fine and others thick; each one leaves its particular character on the painting and each is designed for a particular task.

Roughing-out

The flat brush, be it hog's or ox hair, has hard, compact bristles and great elasticity. This kind of brush can hold a lot of paint.

The elasticity depends on the length of the hairs: the shorter, the stiffer; the longer, the more supple. The brushstroke will have greater covering power if the brush is well loaded with paint..

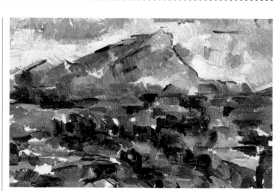

In Monte Saint Vitoire, *which Cezanne painted on many occasions, he experimented with different textures of dry brushstrokes in order to blend the colors; a wide variety of brushes were necessary for this* frottage *technique.*

The Dry Brushstroke and *Frottage*

This type of brushstroke produces truly interesting effects, as it allows the underlying layers of paint to show through.

Such an effect is obtained by using flat, hard hog's hair brushes. Wide, low-quality brushes can also be used. The thickness of the stroke depends on what effect you are aiming for. In any case, the more worn the brush, the better.

The dry brushstroke should preferably be applied when the underlying paint is dry. Do not take up too much paint on the brush, otherwise the effect will be wet rather than dry.

The brushstrokes are not gone over a second time but dragged about in different directions, gradually developing the desired effect. *Frottage* consists of rubbing the dry brush over a textured surface and letting the underlying colors show through.

In this detail from a self-portrait by Rembrandt, we can see the use of the frottage technique which he often used.

Hog's hair brushes.

The Palette Knife as a Complement to the Brush
Applications of Different Types of Brushes
Blending Colors

61

Blending Brushstrokes

For this type of delicate brushstroke, soft-haired brushes are usually used. Both sable and other soft round or flat brushes can be used for the delicate blending of colors. This type of painting does not require high-numbered brushes.

After mixing the color on the palette, it is applied thinly and gently, merely to add the color while avoiding the buildup of textures, etc. Blending one color with another is done with smooth strokes, bringing the colors together and always using fresh paint. When one color "invades" another, it involves constantly going back and forth over the area in order to mix the colors together.

Alternating Brushstrokes

Any kind of brushstroke can be used on a painting, whatever the subject, although it is usually advisable to use more than one size brush.

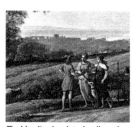

The blending brushstroke allows the painter to create soft color gradations and delicate chromatic transitions.

Colored canvas.

Every brush leaves its particular character on the painting. The effects produced are as varied as the brushes used to achieve them.

Using a single brush for a painting can create surface monotony. It is advisable, therefore, to have always differently shaped and sized brushes handy.

Different Types of Hair

The different types of hair determine the texture left on the painting, so you must choose the right type of hair for each job.

The stiffest is hog's hair, which is thick and firm. Ox hair is a little softer and is ideal for obtaining a gentler texture.

The finest are sable and camel hair, which are particularly suited to delicate work where no texture is required. Sable is delicate and expensive, therefore it should be very carefully taken care of.

You start with a uniform color.

Use an old, worn brush to cover the surface with thinned oil paint.

Result of the frottage.

A Painting by Van Gogh

This work clearly shows the use of three hog's hair brushes. The effect it creates reveals the type of brush used. It varies in thickness and density, "playing" with the elements of the painting.

Doctor Gachet (details)

MORE INFORMATION:
Brushes **p. 38**
The palette knife as a complement to the brush **p. 58**
Painting over dry oils **p. 66**

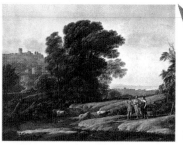

Sable brushes.

BLENDING COLORS

One of the properties of oils most appreciated by artists is their rich color and ease of blending. Oil colors, unlike other mediums, hardly change tone or value when dry. For artists, then, oils are one of the most rewarding paints, as there is no danger of their work deteriorating due to exposure to light or variations of the colors after drying. In addition, as oils have body and density, they permit the easy blending of different colors.

The Subtle Mixture

Oils can be mixed to any harmonic range, thus providing for an infinite number of chromatic possibilities. The paints are mixed on the palette, not forgetting that the resulting color will be seen in relation to the colors already on the painting. The color cannot be properly judged until seen in conjunction with the colors already on the canvas, as the eye captures the chromatism as one overall effect. It is not enough for any color merely to resemble itself; it must combine with the overall tonality of the paint-

Cold range.

Warm range.

The contrasts stand out against the light background.

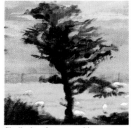

Similarity of tones positions everything at one distance/perspective/plane.

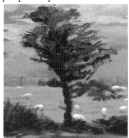

ing. This tonal relationship is based on the complementary nature of colors. For example, it is quite possible to paint skin using greens, provided the chromatic effect complements the colors already used in the painting.

Gradating on the Canvas

To achieve tonal variation of a color using a uniform gradation requires that you alternate mixing on the palette and on the canvas, with blends of the color to be incorporated with the colors already on the canvas.

Gradating from a dark to a light color, whether in the same chromatic range or not, involves adding a new color to the previous one and blending both together. Several brushstrokes must be applied to bring both colors together, until the resulting color becomes "pure," making sure that the mixes do not interfere with the pure colors in any area.

Oils allow subtle gradations of tones and color to be achieved.

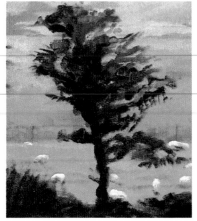

The Contact Between Two Chromatic Areas

Two adjacent chromatic areas always clash if the artist has not painted them with a final color combination in mind. In a painting, adjacent colors affect each other. Light is reflected from an object and carries part of the chromatism to another object. Blending one color with another produces a new chromatism that balances the two chromatic areas. If two primary colors are mixed, this produces a secondary color. If two secondary colors are mixed, a tertiary color is produced.

It is not necessary to mix these colors on the painting, rather on the palette, using the result as an intermediary color.

Tonal Balance

Balancing the tones of different colors should only be done on the palette. A specific color can be tinted by an adjacent color in order to find its place within the harmonic range.

The brush allows you to apply the paint and blend the color at the same time.

A warm chromatic range does not require excluding cool colors.

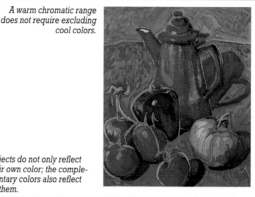

Objects do not only reflect their own color; the complementary colors also reflect off them.

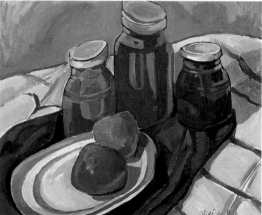

Drawing the Brush over the Canvas

You must also consider the texture left by the brush when you work over any given area. In some cases this texture may prove useful to emphasize different shapes. On others, if a subtle blending of colors is desired, you must use a soft-haired brush in order to avoid the texture that a stiffer brush would leave. Stiff brushes can be used to blend colors, producing a marked, almost "drawing-like" effect.

Blending of Colors in the French Rococo

During the French Rococo period, it became fashionable to paint using pastel and turpentine instead of oils. Essence of turpentine was and still is used to obtain thin paints. This type of painting attempted to blend colors so delicately that the brushstrokes were barely noticeable. This technique reached such a level of perfection that, to a non-trained observer, the oil and pastel techniques are easily mistaken.

Boucher. Woman in Repose.

MORE INFORMATION:

The delicate work of glazing **p. 68**

PAINTING *ALLA PRIMA*

A picture can be painted using just three colors and obtaining a wide chromatic range...
provided you understand color theory. Rapid painting, also called *alla prima,* is
synonymous with spontaneity and freshness, and requires the painter to have a good
knowledge of color. This is good exercise for the hand and mind. A fundamental
requirement is that the artist use larger brushes.

Spontaneity

Rapid painting requires spontaneity, something that is the result of a learning process. First, have a clear idea of the work to be carried out, which requires preliminary sketches. You can only capture the overall synthesis through frequent practice, using just a soft pencil and paper and working rapidly. The same applies when using colors, in that very few are needed to produce the entire chromatic range: yellows, blues, and reds. Starting with this limited palette and wide brushes,

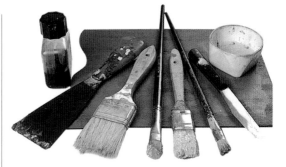

A quick sketch.

a small sketch is then transformed into a painting.

The Mass of Color and the Detail

Begin a quick painting by laying down the general character of shapes and colors. When mixing on the palette, first look for the chromatism of the larger areas or the predominating color, without stopping to work on other details.

Wide brushes are ideal for covering large areas. The main areas of the motif should be painted as "masses" of color, ignoring any details.

Painting and drawing at the same time.
"Negative" painting, covering the background area.

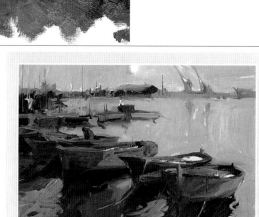

Reflections on the Water

This quick painting was performed in a single session. First, the main areas were painted: the boats and the large area of the ship in the distance. The reflections in the water were added at the end of the session with a few light brushstrokes.

Paint applied direct from the tube.

Blending with the fingers.

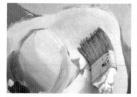

Using large brushes to synthesize the shapes.

Painting over Fresh Oils

Rapid painting involves superimposing layers of oils. Thick brushes enable the artist to add new layers of paint without them disturbing the underlying layers, provided the pressure of the brushstroke is not too heavy and is carried out in a single movement, without repetition.

Wet paint offers a considerable variety of plastic techniques such as the ability to create texture and volume, *sgraffito,* or lifting up the layers with the aid of the brush handle or the palette knife, or blending colors with the fingers. When painting wet over wet, part of the underlying color is always carried along. This is not a problem because, if it occurs throughout the painting, it tends to harmonize the overall color.

Mixing on the Painting

Generally speaking, rapid painting lends itself to mixing the colors directly on the canvas, varying the color with rapid movements of the brush while working on each area.

A knowledge of color theory is essential in this technique because of the effect of each new color on that already present.

Secondary colors can be obtained from two primary colors; if we have a blue surface and want to include some green, all we need to add is some yellow and mix it in.

The same occurs in the case of tertiary colors, using a mixture of two secondary colors.

Bringing out the Underlying Colors

Paint can be applied in different ways depending on the desired effect. If several layers of paint have been applied and a mottled effect is wanted, you can bring out the underlying colors when adding the final brushstrokes. This is a simple process in which two or three brushstrokes of a different color are applied over earlier ones. This produces a vibrant effect if the colors are complementary. If you persist in too much of this technique, however, it is easy to "muddy" the colors you wish to keep pure.

Drying Oils

Oils dry slowly, which is useful for rapid painting as it is always possible to retouch it. If you wish to speed up the process, make sure that the first layers of paint are thin, i.e., with a large proportion of turpentine. If this medium contains 50% linseed oil and an equal amount of turpentine, a greater proportion of the latter is required.

MORE INFORMATION:
Technique: quick sketching **p. 46**
The palette, types of palette **p. 50**

PAINTING OVER DRY OILS

Of the many and varied oil painting techniques, one allows you to paint detailed, accurate work with each different brushstroke, controlling each layer of color, and letting the areas that require further overpainting to dry out first. Many artists use this technique, especially when aiming at more delicate work and when the colors are to be mixed on the palette.

For this painting, each layer of color has been left to dry.

After drying the first layer, paint is applied with an almost dry brush.

Length of the Painting Sessions

This type of work requires patience and accuracy, and the color mixing on the palette is important right from the start. Although the mixed colors need not be the definitive ones, as they can be altered later on, they should be as near as possi-

Meticulous Work

A fully detailed sketch, both of the subject and surrounding elements, is the basis for developing a fine technique. A fully completed drawing allows the artist to concentrate on the color and shapes, with no need to draw with the paint.

First, the larger areas are roughed-out with thin oils. In the same way, the remaining chromatic areas of the composition are painted, carefully working on the tones and shapes, before getting into detail.

Once the initial layer of colors has been applied, it is left to dry for two or three days.

Further sessions can add a wealth of detail, while each layer that is to be worked must be allowed to dry before continuing.

Detailed areas are completed at the end of the work.

It is essential to define the most luminous details when contrasting light and dark.

For finishing off the features, lightly colored, flowing brushstrokes are used.

MORE INFORMATION:

The delicate work of glazing **p. 68**
Rectifying and Pentimientos **p. 90**
Finishes and varnishing **p. 94**

ble to those of the subject.

This system involves completing in each session those areas you wish to let dry before new sessions are started. In this way, as the painting progresses, new areas can be started while finishing others.

Dry finishing requires patience and time.

Common Mistakes

After long, painstaking sessions, you may find that a series of problems arise, such as the paint wrinkling, cracking, separating from the canvas, and variations in color taking place.

All this can be avoided by using the correct technique. In particular, you should always apply heavy paint over thin to prevent the paint from cracking. The painting should not be too saturated with oil so as to avoid wrinkling.

Consider compatibility when mixing colors: cadmium yellow should not be mixed with copper colors; vermilion is neither compatible with copper nor lead white colors, and neither is cadmium red. (A copper color is, for instance, opaque green.) Dark colors dry quickly, so should not be used in the first layer, nor to cover large areas, nor in thick layers.

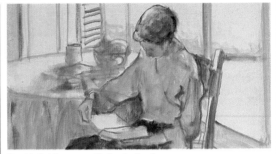

A quick sketch prepares the tonal valoration.

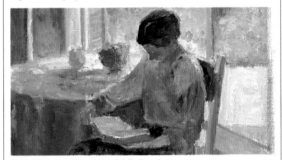

A dry first layer allows more detailed work.

A common mishap is the paint cracking.

Producing Effects

Numerous optical and plastic effects can be obtained over a dry layer of oils. Oils can be transparent or opaque, and different results can be achieved depending on the type of brush. *Frottage* is performed by rubbing the painted area with an almost dry brush, just letting the underlying layer show through. Glazing is a transparent, liquid application that tinges a certain area. These effects can be used in combination.

Working over Dry

A reasonable length of time between drying each layer was necessary to produce this work. Applying *frottage* to oils over dry lets the underlying colors show through without blending the colors. To achieve this effect, the underlying layers must be completely dry.

THE DELICATE WORK OF GLAZING

One of the most highly valued qualities of oils is undoubtedly the ability to adapt to the artist's many needs. Other mediums are limited by chromatism, brilliance, and texture. Oils, on the other hand, can be used as a dense, opaque medium, with superimposed layers of paint, blending the colors, or as a semi-transparent medium, creating layers of color that leave the underlying dry painting exposed.

What Is a Glaze?

A glaze is an almost transparent layer of color which, applied to certain areas of the painting, alters the values or colors underneath. For this, the oil is thinned and applied in fine layers. Glaze work is usually carried out over dry oils, but can also be used on freshly painted work (although it then loses much of its brilliant effect). Glaze "plays" with the underlying colors, tinting them to create an atmosphere between the different layers of the painting.

Method

The base for glaze is composed of equal parts of turpentine and oil. Glaze is a medium that requires just the right amount of oil and pigment for the result to be both transparent and yet contain color. This is achieved by adding the right amount of color carefully to the oil with a fine brush. After it has been mixed, it is applied with a fine brush to the area to be glazed. It should always be applied to a light-colored area, because, being transparent, if applied over a dark area it would lose its effect and leave an unpleasant residue.

Painting with glazes.

Turpentine

Oil

Adding Pigment to the Oil

Pigment is always soluble in oil, although some pigments are more so than

Variations of tone produced by glazes.

Applying a dark glaze.

The Traditional Method of Glazing

The shadows and flesh colors in this painting were achieved using colored glazes. Each glaze was applied over dry oil and each layer was left to dry before adding the next.

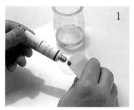

Adding color to the medium.

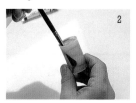

Stirring the mixture.

PREPARING A GLAZE

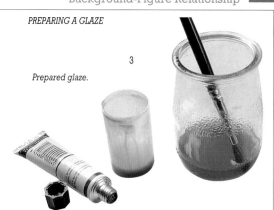

Prepared glaze.

3

others. Reds and earth colors can pose problems such as the formation of lumps of dry pigment. This should be guarded against as it can spoil the glaze work.

The oil can also be colored by adding small amounts of ready-prepared oil paint. This is a failsafe method as the pigment has already been dissolved in a mixture and the oil only needs diluting in the medium.

Any Special Oil?

Glaze work can be so subtle that the slightest yellowing of the oil can spoil the desired color. While linseed oil is

Walnut oil.

usually used for thinning oils, walnut oil is more advisable for glazing. This product is totally transparent and produces truly fine results.

Patience and Work

Glaze work is similar to watercolors in the sense that the depth of color is obtained through transparency. It differs in that while the watercolorist tries to obtain the color right from the first layer, in glazing the desired color and luminosity are obtained using successive layers after each previous layer has dried.

To obtain a luminous glaze, the base color should be light. This color can then be progressively darkened to obtain the desired effects.

Drawbacks of Using Driers

One of the methods artists often use to speed up the drying process of glazes is the use of driers. This is a mistake, as it not only spoils the texture and luminosity of the painting, but can also produce a cold tone.

To accelerate drying, light

varnishes, such as Dammar varnish can sometimes be used. Although it looks a bit dark in its container, once it has been applied it adds gloss to the painting.

Surface damaged by excessive amounts of drier.

Drier.

MORE INFORMATION:

What is oil **p. 6**
Composition of oils **p. 10**
Different types of oils **p. 18**

BACKGROUND-FIGURE RELATIONSHIP

One of the areas that poses most problems when composing a painting is the relationship between the background and the figure. Once the subject is chosen, the artist not only focuses on the main figure but also on the surrounding elements. Depending on how this is done, the resulting painting can vary greatly. The technique of oils allows the painting to be constantly changed and the background-figure relationship can therefore appear in many different ways.

The Theme and the Aim of the Painting

Once the theme has been chosen, the aim of the painting must be defined by framing the subject so as to achieve an acceptable composition. The color, harmonic range, shapes, type of brushstroke, background, and figure are all points to consider. Each element of the painting establishes a relationship with every other element.

Simplifying and synthesizing are the main objectives.

Oils are an excellent medium for experimenting

If you compare with the model above, it is obvious that in the painting below, the background has been altered and several highlights included in order to strengthen the background-figure relationship.

and making changes. The palette knife is particularly useful here for correcting details or removing elements that may detract from the painting.

The relationship between the elements springs from their chromatic difference.

Unity of Pictorial Elements

There are various relationships between the different elements, i.e., shapes, color, texture, etc. Each is related to the rest in one particular way or another.

For example elements can be related by color, in which case it is necessary to bear in mind the effect of one color upon another within the chromatic balance.

The Color Relationship Between Figure and Background

The figure is not represented as a specific, individual element of the painting, but rather as what the artist wishes for it to represent. While in a portrait it is obvious that the theme is the figure itself, in a landscape it might be the element that the artist wishes to highlight. Generally speaking, in a landscape it is easier to balance the relationship between figure and background than to deal with a figure that is isolated on a plain background.

The background affects the overall color harmony and must work chromatically with the figure. This combination or association lends unity and coherence to the painting.

More importance is often attached to the elements surrounding the figure.

The brushstroke creates the rhythm of the painting.

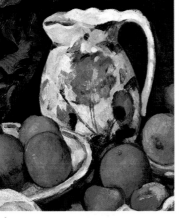

Types of Brushstroke

Color and clarity, plus the abstract interpretation of the objects, depend on the type of brushstroke. One way of emphasizing the relationship between background and figure is to apply a different brush treatment to each. Clear, energetic brushstrokes to define the most important areas of the composition and a more monotonous brush treatment of the background can emphasize the relationship between the two.

The dynamics of the brushstrokes depend on the range of brushes used, to produce a different treatment according to which area of the painting is being worked on. If a particular treatment is chosen for the figure, the background can be painted using another type of brush in order to suggest different planes and textures.

This does not mean that the background does not require careful painting. Quite the opposite: the figure and background are closely related and the chromatic treatment of the background can alter the values of the figure.

Establishing the Distance Between Background and Figure

The distance between the background and the figure may or may not be defined.

The Portrait and Its Integration in the Painting

The background-figure relationship in this painting has been established by harmonizing the colors.

A cold chromatism, even for the flesh colors, integrates the figure into the background in perfect balance.

Darkening the Background

The classical solution is to darken the background to make the figure stand out.

If you choose to contrast the background and the figure, both planes are automatically separated, although the chromatism of the painting can bring them together on the same plane. This may be achieved by adding a dark edge to the outline of the figure that is to be highlighted. Once the major areas of the picture have been painted, the figure is defined with a fine brush.

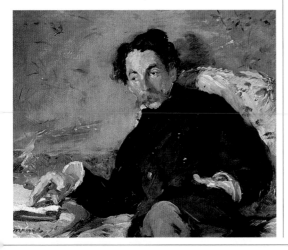

Darkening the background to highlight the figure.

MORE INFORMATION:
How to use backgrounds **p. 72**
Perspective, volume, and shadows **p. 86**
Chiaroscuro **p. 88**

HOW TO USE BACKGROUNDS

A painting is much more than the central subject. Everything that surrounds it also forms part of the work. This background can be treated in many ways, whether highlighting the figure or not. The subject does not decide the background, the artist does. In other words, a still life or portrait does not have to include the background. This is where the artist's subjectivity comes into play.

Effects of the background-figure contrast.

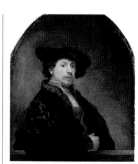

The lighting affects the figure and the background.

Backgrounds to Portraits

The background is especially useful for portraits. The portrait studies the personality of the person portrayed and the background should serve to reinforce this personality. The character of the figure changes with the background. Within the harmonic range used, the treatment of the background can be textured or smooth. If the background is smooth, the figure can be emphasized by illuminating around the form. A textured background can be more abstract, working and mixing the paints on the canvas as though it were a palette.

A Neutral Background

A neutral background is a simple, non-committed way of finishing a painting. Using the same harmonic range as the model, a color is chosen among the complementary colors that least distracts from that of the model. For example, if we are working with a warm range, a cold background can be neutralized by mixing in some of the warm range of color. A face or still life, with a predominance of Naples yellow, alizarin crimson, burnt sienna, and white may benefit from a neutral background formed by Cerulean blue, yellow, a little burnt sienna and white. This will produce a broken green that harmonizes with the warm tone of the figure.

Backgrounds that Highlight the Figure

This kind of background makes the model stand out. A monochrome chromatic range is established using the complementary colors of the model. This relationship between complementary colors heightens the main elements.

The rhythm of the brushstrokes "fills" the painting.

The figure stands out against a neutral background.

A background that uses the complementary color of the model highlights its importance.

The Background in a Still Life

A still life in oils can be striking because of its composition or use of color. Here the background plays an important part, as it can isolate the subject or envelope it.

This kind of background can be painted in chiaroscuro or using a common element, such as cloth, curtains, or graded backgrounds that play with the light.

The Brushstroke and the Background

The type of brushstroke depends on the purpose of the background. A painting may require a type of blending textureless brushstrokes, using flat brushes, and mixing the color on the palette and transferring it to the colors already on the canvas. Another kind is the free, flowing brushstroke which

Flowing brushstrokes create texture.

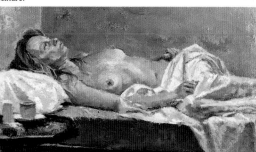

can be mixed on the palette or on the canvas, lending texture to the painting as it mixes with the previously applied paint.

Combining the chromatic harmony through careful use of light.

Botticelli and the Imaginary Background

During the Renaissance, there was a tendency to highlight the main figure against a neutral background landscape. The background often had little connection with the main figure. The link between the background and the figure was therefore its chromatic relationship.

Weights and Masses

The background of a painting reflects part of the structure and the composition, therefore the distribution of weight and masses requires careful study.

Balancing the painting involves all the elements it contains: shapes and colors both have a specific weight that works on the same principle as gravity. Dark colors weigh more than light colors, and the larger the masses the more weight they have in the composition.

Depending on the main figure, the masses and colors should usually be evenly balanced in the painting.

MORE INFORMATION:

The delicate work of glazing **p. 68**

Perspective, volume, and shadows **p. 86**

Chiaroscuro **p. 88**

TEXTURES

Oils can produce a variety of effects, but undoubtedly one of the most interesting is their capacity for being manipulated. Oils are dense and retain their thickness after drying, so they remain exactly as the artist applied them. This allows the artist not only to paint, but to create texture, experimenting with the marks left by the different tools.

Oils are very dense.

Modeling oil with brushstrokes.

• Small dots of oil are added to a ready-painted surface.
• These are then mixed with a large quantity of oil on the painting itself, leaving the mark of the brush.
• Large movements of the palette knife are used to finish the main areas of color, leaving the modeled oil visible.

What Is Texture?

Texture is the appearance of the surface. It can be understood in two ways: as a repeated variation in the level of the surface of the paint, or a smooth, undisturbed, surface.

Textured painting was unknown until the arrival of oils. The first oil paintings were completely smooth and the brushstrokes barely noticeable. The brushstroke came into its own with Velázquez and Rembrandt. Since then, the brushstroke and oils are used to model not only the color but also the volume of the painting.

Painting a seascape in oils.

All Objects Have Texture

An object is recognized by its appearance and touch. A large expanse of sand can be represented using earth colors that imitate both the color and the surface of the subject, plus some textured volume. The effect produced in this way is much more realistic.

Creating Texture

There are several ways of creating texture using the brush and/or palette knife.

Texture created using a brush.

Additives for Texture

Texture can be created in oils not only by modeling the paint on the canvas but also by using additives to create an even texture over the entire surface of the painting.

Modifying the tone of the texture.

Flowing brushstrokes create luminosity in a still life.

Relief produced by modeling with the palette knife.

Different Textures

Several different methods have been used in this painting to create texture with added powdered marble. The palette knife has been used for the larger areas in order to balance the planes, while the relief of the lines has been added using the brush.

All kinds of powdered minerals, provided they are not oxidizable, can be added to the paint. The most commonly used are powdered marble, gypsum, carborundum, hematite, and washed sand.

A wide range of additives can be found in specialized stores.

These minerals are economical and easy to use—just mix them on the palette with the desired color, and apply them with a brush or palette knife.

Light Determines the Texture

Adding texture to an oil painting involves altering the surfaces. This difference in the surface gains volume thanks to reflected light, so the more material mixed with the paint the more apparent the irregularities are.

When a certain texture is obtained, the painting will change in accordance with the light.

Sgraffito.

Gradations.

Frottage.

Blending.

Mottling.

Texture via free brushstrokes.

MORE INFORMATION:
Additives to create texture in oils **p. 76**
Working with different materials **p. 78**

ADDITIVES TO CREATE TEXTURE IN OILS

As we have seen, there are as many textures that can be obtained in oil painting as there
are different materials. Each material has its own characteristics and produces different
results. Each material acts in a different way depending on its density and texture,
although all have a common denominator: they do not dissolve like pigments, but are
simply added to the medium to produce a relief effect.

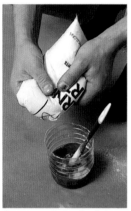

Gypsum powder is a fine, light additive.

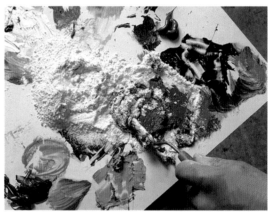

Mixing oil paint and gypsum powder.

Powdered Gypsum

This is the finest of the materials that can be used. It is light and stable and comes in different thicknesses, from the size of fine talc to coarse sand. It is easy to use and can be crushed to produce a finer texture.

Being a powder, it needs to be well mixed with the oil to prevent dry lumps from forming. The texture obtained varies in accordance with its thickness. When used in fine powder form, the texture is light while at the same time lending body to the medium and making it more malleable.

The amount added should not saturate the medium or the paint will lose its adherence to the canvas when be-ing worked. The more powder is added, the more the paint loses its adhesive power, in which case a little more paint should be added.

Powdered Marble

This is similar to gypsum powder but harder and heavier. It should be bought in the size you intend to use as it is difficult to grind.

It may sometimes produce an irregular effect, and tiny particles can be seen.

It is simple to mix with oil and is applied using the palette knife.

Powdered marble can be ground in a mortar or on a metal plate. If a metal plate is used, grind a small amount lightly with a hammer.

Applying oil paint with an additive.

Textured effect of the medium.

When the paint has been mixed, the sand is added and stirred until it forms an even mixture.

Sand

Sand comes in different thicknesses, is extremely hard, and contains different minerals, from granite to calcareous rock.

It should be washed and dried before use to remove completely any sea salt, although it can also be bought ready-washed.

As with powdered marble, it mixes easily with oils.

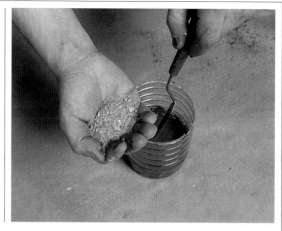

Varnish and Additives

If a large amount of additive is used, oils tend to lose their adhesive and binding power. Varnish will reinforce the consistency of the medium and highlight the surface after it has dried.

Texture and Palette Knife

The palette knife is commonly used for textured work, both to transfer the paint to the canvas and to shape it.

Hematite and Other Materials

Hematite is a heavy metal with an even texture that mixes well with oils and can be applied both with the brush and the palette knife.

It is not suitable for thick layers or impastos.

There is a long list of materials that can create textures, but here we have had to confine ourselves to only a few of them.

Following a time-honored tradition, each painter must experiment with new materials and with combinations of known materials.

The palette knife is essential for modeling paint that has any kind of additive.

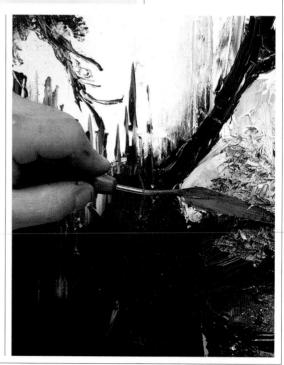

MORE INFORMATION:

Alternation and compatible techniques **p. 54**

Textures **p. 70**

WORKING WITH DIFFERENT MATERIALS

Oil painting is ideal for adding earth or powdered minerals, but this is only one way of creating textures. Other materials can be used: found objects, plaster, broken plates... These kinds of materials can be used in all types of subject matter and style, allowing a wide range of possibilities for experimentation through the artist's imagination.

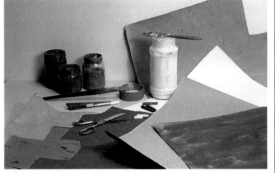
Ready-prepared cardboard and paper painted with oils.

Preparing cardboard and paper with paint and color.

Two pieces of paper are cut out and adapted to the shape.

Materials and Texture

The material should not be confused with the texture, although they are obviously closely related. Texture can be created by working with the oils themselves without adding any material.

Any material added needs to have sufficient volume and consistency to be visible as a composite element of the painting. These materials should not be oxidizable, for example, plastics, cardboard, wood, cloth, or plaster.

Elements, Materials and Surface

Almost any material can be added to oil provided it is not greasy. This style requires more attention to composition than traditional painting, so the distribution of the materials in the painting must be carefully studied beforehand.

Understandably, any non-elastic material is difficult to attach to a soft surface such as canvas, so compositions using different materials (collages) must be made on rigid surfaces and, if possible, firmly attached (using nails, staples, etc).

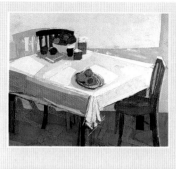

Always Prime First

In this work, the effect has been achieved by using a combined technique. Oil, being a fatty medium, would spoil the cardboard and paper if they were not first primed.

The Relationship Between Oils and Other Materials

Oils are a strong adhesive when dry, but they cannot bind other materials if used in thin, diluted coats. There are therefore two alternatives, either use large amounts of oil, or attach the materials with another adhesive and then paint over the result.

Any material can be lodged in thick layers of oil paint, but sharp pointed items should be avoided.

Tendencies

The thematic possibilities when using other materials are greatly increased and open up many new creative

After attaching the cardboard and paper, you can start to add paint, remembering to paint thick over thin and oils over plastic.

horizons. Adding materials is practical and fun. For example, in a portrait, certain features can be represented by objects instead of color: buttons for eyes, pieces of plastic for ears, broken plates for the background, and so on. For abstract works, the artist can concentrate on the purely compositional aspects, alternating shapes and color, creating near and distant planes.

Techniques and Mixtures

As you have seen in this chapter, there are infinite possibilities when applying different materials to oils. This technique requires a knowledge of the materials and how they combine with oils. Here is some advice:

• Materials should be thin.
• Heavy and oxidizable materials should be avoided.

• No absorbent materials should be used.
• Prime paper and cardboard with an acrylic sealing agent.
• Use rigid, primed surfaces (wood, canvas-covered cardboard).

Collages

This is a composition using fragments of paper or cloth. Any magazine or any kind of cloth can be used. The combined oils-collage technique requires attaching the col-

A work by Tapies, a clear example of the use of different materials.

lage to the surface with glue or acrylic and then painting over the areas, while adding certain elements as you work. Collage is the simplest of the techniques in which different materials are added. It does not require thick layers of paint, although certain materials such as magazine paper or fine cardboard need priming beforehand.

MORE INFORMATION:

Other sealing agents for a latex surface **p. 28**

Alternation and compatibility: thick over thin **p. 54**

Additives for creating texture **p. 76**

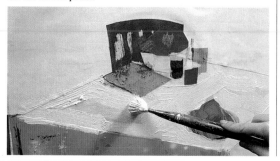

FLESH COLORS AND HIGHLIGHTS

One of the most attractive aspects of the oil medium is its capacity of mixing flesh colors. The artist who has mastered the art of mixing colors can produce brilliant and surprisingly beautiful results. There is no formula for obtaining the colors of the human skin, nor is there a specific flesh color, since the colors of a person's flesh depend on the colors that surround the subject and the type of illumination present. In fact, on studying your model, you will notice that there is an almost infinite number of chromatic hues, and reflections of light.

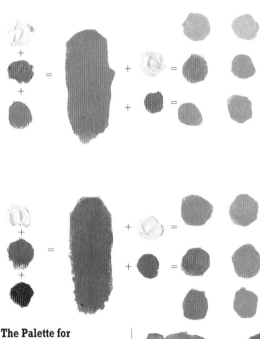

Light and Dark Skin

Having understood that there are no specific formulas for obtaining flesh colors, it is important to know that there is, in addition, a wide variety of skin tones. Light skin, for instance, is treated in a completely different way than dark skin. When painting light skin, concentrate on obtaining hues that create the transparency of a white person's skin. In addition, highlighting has a significant effect on the color of flesh. As a general guideline, the color of light skin is obtained with a mix of Naples yellow, red, white, and blue.

Flesh colors and their tonal variations.

All color ranges can be employed to obtain a flesh color.

The Palette for Flesh Color

There is no such thing as a flesh color. The color of a person's skin depends on the colors that surround this person. All color ranges can be used to create a flesh color, although black is not recommended since it tends to muddy the other colors. Each person's skin color undergoes tonal alteration depending on the surrounding chromatic atmosphere.

A palette of light flesh colors.

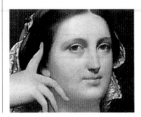

This light skin was obtained with Naples yellow, red, white, and blue.

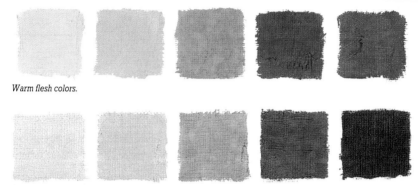

Warm flesh colors.

Deep cool flesh colors.

For dark skin colors, depending on the atmosphere and highlights of the model, more earth colors and blues are commonly used.

The Lights and Reflections

There exist a number of colors commonly used by artists to obtain flesh colors. As you can see, the chromatic range is wide enough to obtain all necessary flesh colors.

• Warm colored flesh:

Luminous flesh. Plenty of white, a touch of yellow, and a little cadmium red.

Pinkish flesh. The above color plus more yellow and cadmium.

• Other mixes:

Yellow ochre. Yellow and white in equal parts, a little cadmium, and a little blue.

Raw umber. The above color plus more cadmium, yellow, and blue.

Indian red. Cadmium and white with yellow.

• Cool flesh colors:

Flesh Highlights. White and an extremely tiny amount of yellow, cadmium and blue in similar quantities.

Cool flesh color. White, a little yellow, and cadmium until a pale orange tone is obtained, to which blue is

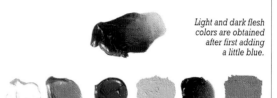

Light and dark flesh colors are obtained after first adding a little blue.

The Color of Flesh

Here a cool chromatic range influences the flesh colors, and has been resolved by increasing the amount of burnt sienna and blue.

gradually added until the desired tone is achieved.

Medium cold flesh color. The proper intensity is increased by adding a little more yellow and blue.

Shadow flesh color. White, yellow, and blue are mixed together until a pale green is obtained, adding if neces-

sary a little more yellow and carmine to it.

Deep shadow flesh color. With a cadmium tendency. To achieve a purplish tone with cadmium, blue and white and a touch of yellow is added. Burnt sienna and white and blue can also be added.

Details of the highlights in a brown skin.

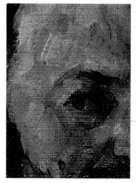

MORE INFORMATION:

The highlights on flesh **p. 82**

Solving features, nose, eyes, mouth, ears **p. 84**

THE HIGHLIGHTS ON FLESH

We have already seen the chromatic possibilities of flesh, as well as the subtle hues produced by the surrounding colors. The use of different colors in a realistic painting are based on the incidence of light.

It is obvious that light enhances colors, and the absence of light reduces colors to shadows. But light also "paints" objects: close observation reveals that the model's skin is not homogeneous in color. Light has a significant effect on color, illuminating it or reducing its highlights.

The Incidence of Light

The color of a model depends on its volume, the surrounding colors, and the nature of the illumination. By altering these three factors we can change color radically.

The volume is created by light and shadow and establishes the maximal point of light in the composition. The maximal point of light in a painting is, of course, the brightest. One way of working this out is to sketch the chromatic range you are going to use on a separate piece of cardboard in order to try out different color combina-

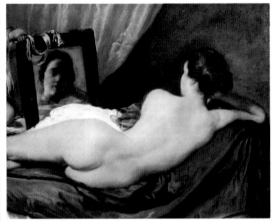

The highlights on flesh depend on the direction of the light as well as the objects that surround the model.

The direction and intensity of the light vary the highlights and color of flesh.

tions for possible inclusion in the picture.

The Use of White

White is the most commonly used color of all in the oils medium. Only on rare occasions is it applied directly to represent the maximal degree of light. Bearing in mind that colors reflect the surrounding colors, the maximal highlights that can be used in flesh tend toward white plus the color range of the chromatic atmosphere within which the model is placed.

Toning and Exalting

No chromatic range automatically rules out the choice of colors in other ranges. Human skin is not a smooth homogeneous surface; there are an abundance of hues of green, blue, earth, etc.

The overall tone or hue establishes the colors that envelop the model and define the different planes of the picture. The colors of maximal light are, of course, brighter than those in shadow.

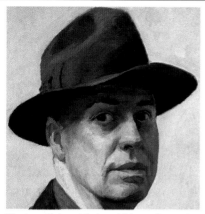

The chromatic tones take in cool (blues and greens) and warm colors.

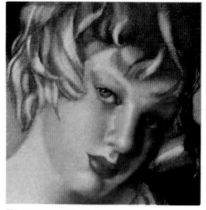

The tones are highlighted with cool colors.

Oil and Artificial Illumination

Lighting conditions affect the color of the model and alter its highlights and shadows.

Artificial light allows you to obtain certain effects and even helps in achieving specific color ranges. It can transform an object from one color range to another, and shorten or lengthen both shadows and forms. Transferring light onto the canvas can be achieved by blending the colors on the canvas to create subtle mixes that give rise to barely noticeable transitions from light to shadow or, if the light is bright, to create harsh contrasts.

Artificial light accentuates shadows and darkens as well as tones the flesh.

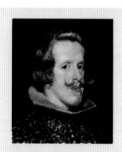

The Highlights on the Flesh of Velázquez's Models

The highlights can be resolved in many ways, depending on the source of the light and the way in which the paint is handled. In this work, the master used his intuition to resolve the flesh colors by playing with the background contrast and providing the skin with a pastel-like tonality with the aim of emphasizing its delicacy.

Highlighting with Natural Light

Natural light has a completely different effect on skin and forms from that of artificial light. With natural light, the highlights and chromatism depend on the position of the model with respect to the direction of the light. The shadows and their dark-to-light transitions depend on the time of day and atmospheric conditions.

Highlights are not as accentuated as they are under artificial light, so that the color blends and shadows are softer, and the flesh reflects less of the surrounding colors.

Oil enables an almost limitless number of color blends.

MORE INFORMATION:

Blending colors **p. 62**

The delicate work of glazing **p. 68**

Flesh colors and lighting **p. 80**

SOLVING FACIAL FEATURES: NOSE, EYES, MOUTH, EARS

The oil technique allows you to work on a single subject in many different ways. However, it is essential to have a clear idea of the volumes before you start representing the different parts of the body. One of the great advantages of oil is the possibility of changing any aspect of the painting at any stage, a fact that makes it an ideal medium for painting human figures.

Facial features are also foreshortened.

The Volume in Foreshortening and Oils

Foreshortening enables us to emphasize the volumes of the figure. In other words, foreshortening is a technique that allows the artist to present a three-dimensional object on a surface.

Human features are defined by the highlights and shadows cast on the surfaces. Given the tonal scale of the picture, it is possible to translate the volumes of the model into lights and shadows. The initial roughing-out on the canvas should summarize what the volumes of the face will look like, thus establishing:

• The tonal design of the painting.
• The placemant of the features and proportions.
• An approximation of the foreshortening.

Working the Volumes and Highlights

Drawing should always be present in any pictorial work. Each person has his or her own unique features. A correct visual analysis allows us to develop a reasonable likeness of the face. The first step is to paint a general impression of the face without including any details, and at the same time to indicate the various planes of the face and the relationship of the different features. The adding of highlights and shadows will finally bring the face, neck, and hands to life.

The Nose

The nose is one of the most prominent features of the face. Having reduced the head and its parts to basic geometric shapes, it is now easier to draw the nose in foreshortening.

The question of the nose is governed by the length, the angle of the nasal bone in relationship to the face, and by the width and distance between the outer edges of the nostrils and their distance from the eye sockets. Since the direction of the brushwork gradually constructs the shape of the nose, a long brush should be used when we are defining the length of the nasal bone, and a short brush with equally short strokes

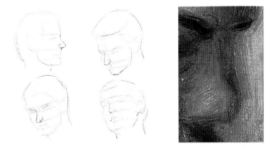

The position of the head and the degree of its inclination gives the nose volume.

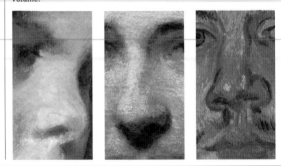

for representing the nasal wings and the shines.

Volumes are created by highlight and shadow; therefore, the nose stands out because of its lighter value.

Different positions of the head for studying facial features.

Eyebrows and Eyes

The execution of the eyes depends on correctly establishing their position in the eye socket; this placement creates a shadow between the nasal bone and the eyelid. It is also essential to take into account the difference between the curve of the upper and lower eyelids.

Because eyes are often "drawn" rather than painted, we usually only need a change in color to indicate the eyes, eyebrows and eyelids.

Ears

The ears can either be carefully drawn or be left as mere sketches. Rather than drawing the ear in great detail, it is more important to indicate its shape and proper position with respect to the rest of the skull.

The curves of the outer ear can be executed with a subtle and lighter tone with a fine brushstroke.

From a foreshortened point of view, the ears are seen as planes.

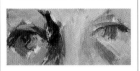

Mouth

Pictorially speaking, the mouth is defined by the change in value produced by the shadow on the lips. Lips usually stand out on the face, emphasizing their shape and length.

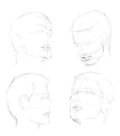

The position of the mouth varies on the face's plane.

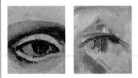

Different interpretations of eyelids.

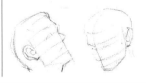

Goya and the Gesture

Goya is renowned for mastery of capturing features and gestures. His method of painting, a precursor of Expressionism, attempts to define the inner attitudes of his subjects. The facial features are executed with rapid, free brushwork that plays with the chiaroscuro.

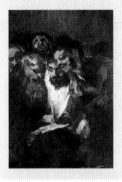

MORE INFORMATION:
Flesh colors and lights **p. 80**

PERSPECTIVE, VOLUME, AND SHADOWS

The planes of a painting can be indicated by their drawing and color. This fact, together with the rules of perspective, enables us to represent volume by means of basic guidelines. The play of lights and shadows enables the painter to create a sensation of depth and volume among the different elements in the picture.

Distant colors take on a bluish tendency.

The Use of the Third Dimension

Colors are related to distance. For instance, the farther away a mountain is to the spectator, the bluer it appears. This phenomenon is due to the filtering effect of the atmosphere. If we transfer this to the canvas, it is possible to represent the third dimension by means of color and a succession of planes. Try out the following exercise: draw a truncated triangle and paint a color gradation from a warm earth color, gradually adding white and blue until the earth color has completely diminished. The result provides a perfect example of how color works in perspective.

Perspective created by means of successive planes.

Planes and Color

The combination of color and superimposing of planes provides us with a splendid way of achieving depth without having to employ the rules of perspective. On the other hand, there are occasions where it is absolutely essential to apply the rules of perspective in order to give the subject three-dimensional reality.

By indicating the point of view of the spectator in the foreground, we can establish a series of imaginary lines that run from the spectator to a point on the horizon (the vanishing point). The sizes of the objects between the spectator and the horizon line are determined by the convergence of the imaginary lines.

The Direction of Light

A painting can possess all manner of depth. The subject may be situated in a way that is determined by

The illumination has an important effect on the composition.

the perspective and the successive planes. This effect of volume depends on the direction of the light. General illumination tends to create flat colors and to suppress shadows, while lateral lighting heightens contrast and incorporates a new color range into the painting. The effect of lights and shadows, known as *chiaroscuro*, brings the subject to life and lends it a dramatic effect.

Daumier's Backlighting

Daumier obtained perfect backlighting with a strong color and value contrast. There is no chromatic deficit; each zone is dealt with in all its possible ranges. Visually, this color contrast produces a backlighting effect.

Daumier, *The Washerwoman*

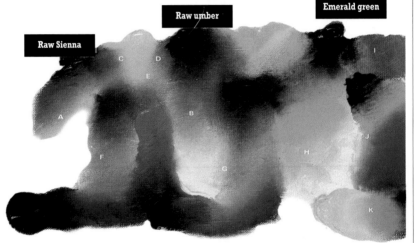

Raw Sienna

Raw umber

Emerald green

Chromatic variations of mixes:
A = Raw Sienna with white
B = Raw Sienna with white
C = Lemon yellow warm
D = Lemon yellow cool
E = Greenish lemon yellow

F = Burnt umber mixed with blue and white
G = Raw umber with white, green, and blue
H = Emerald green and white
I = Green and ochre
J = Ultramarine blue, green, and white
K = Yellow and blue

The Shadow Palette

The shadows in a painting depend on how the model is illuminated. The more intense lighting is on the model, the greater the intensity and depth of shadows.

There is no such thing as a specific shadow color. The colors of shadows are found among the colors you are using to paint your subject. It is useful however, when you want to employ a wide range of colors, to not reduce the range of tones to black, but employ a cool, warm, or template range instead.

Illuminated and Shadow Zones

Note how the light outlines the form in shadow. The chiaroscuro is created by painting radical contrast of light and shadow without intermediate tones. The effect of the chiaroscuro combined with the study of perspective lends the painting a sensation of depth and drama. Backlighting is achieved by placing an object in shadow against a strongly lit background. Note that in its darkest parts it is possible to observe a clarity of form. However, remember not to overuse white in these light areas.

MORE INFORMATION:
Background-figure relationship **p. 70**
How to use backgrounds **p. 72**
The Chiaroscuro **p. 88**

THE CHIAROSCURO

A highly realistic, almost theatrical, sensation of volume can be achieved by alternating lights and shadows. Thanks to the chiaroscuro, the relationship between the background and the figure is accentuated and sometimes there is even an interdependence created between them. This relationship can be so strong that the whole becomes more important than any of its parts.

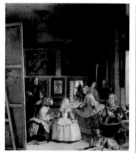

Tonal determination emphasizes the points of light.

A good grasp of tones enables the artist to understand color in chiaroscuro.

Monochrome Works and Oils

The monochrome work executed in oils is based on tonal determination exclusive of color. First we have to evaluate the maximal and minimal points of light, which will enable us to decide on the appropriate color tones although we really are painting in black and white.

Tonal Evaluation

It is not essential to paint a monochrome picture in order to understand the chiaroscuro. Nonetheless, it is useful to establish the basic tonal values during the initial roughing-out of the canvas. To execute a correct determination of tones and translate them into a series of one-color values on the canvas, it is worthwhile painting some monochrome preliminaries on a piece of white cardboard or other scrap surface.

Dramatic Shadows

There is a logical reason for using a single chromatic range when painting a work in chiaroscuro, since the shadows cast by an object possess the same basic color as the illuminated object.

The shadows in the second of these two versions of the same theme have been darkened.

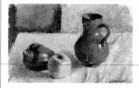

Exaltation of Light

The degree of contrast between lights and shadows is established by the difference between the two areas, a difference that is not only created by the darkness of the shadow but by the relationship of the darker color to all the others. When a maximal point of light is established, all the other colors will be darker by comparison, but maintain-

The approximation of colors translated into tones.

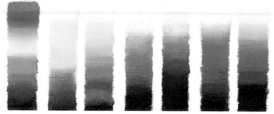

ing the gradation of the difference. For instance, if the maximal point of light is deep ochre, all the other colors will be subordinate to this one, as well as the different hues found in the shadows.

Play of Contrasts

The radical variation of light and dark tones creates surfaces on a plane. Such contrasts can be accentuated according to the interest it gives to the element being painted. A painting's composition does not depend so much on color masses as on the distribution of the different points of light.

The play of contrasts and tonal evaluation.

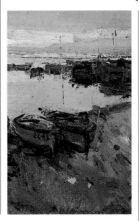

The contrasts in the foreground heighten the luminosity of the background.

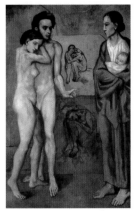

The brightest tones are indicated by maximal light.

Points of Interest and Perspective in Chiaroscuro

The representation of forms in perspective does not depend exclusively on the lines of the initial drawing, since the perspective produced by the lights and shadows supplants that created by the drawing of the perspective of planes. Although the points of interest are accentuated by light, remember that the brightness and size of these points of light will decrease in perspective, that is, they diminish in brightness and size as they recede into the background.

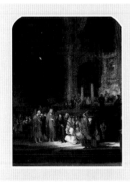

Rembrandt's Chiaroscuro

Rembrandt's method of perspective is magnificently demonstrated here. In this composition the most important personages are in the stronger light, while others, although closer, are more in the shadows and thus less prominent.

Rembrandt, *The Holy Family.*

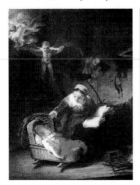

MORE INFORMATION:

The background-figure relationship **p. 70**

Resolving backgrounds **p. 72**

Perspective, volumes, and shadows **p. 86**

PENTIMENTOS AND CORRECTIONS

Oil is ideal for adding and deleting things. Oil maintains its luminosity once dry so that the value and color desired by the artist remains permanent.

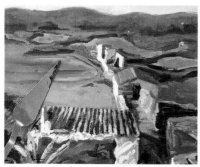

The palette knife can be used for removing wide areas of paint.

Repainting areas with thin glazes.

Oil, Ideal for Corrections

It is possible to paint a good picture and nonetheless not feel happy with the result of a specific part. If the oil is still wet, you can correct it right away by applying a new application of color over the former. A thick layer of fresh paint can be removed with the palette knife, leaving the space ready for a new layer.

Thanks to the plasticity of oil, changes can be carried out on both wet and dry oil paint.

The Opacity and Transparency of Oil

Oil can be applied in dense opaque layers or in completely transparent ones. These qualities facilitate making changes as we encounter them. A specific color such as Naples yellow can be modified with thin layers of a cool or warm color, without any need to apply an opaque layer.

Undesirable colors and forms can also be corrected with heavy, opaque paint.

Technique and Pentimento

Pentimento in oil painting requires sound knowledge of oil painting techniques and of the behavior of color.

A new layer of paint must always be thicker than the previous one unless the surface area you are about to correct is completely dry.

With time dark colors tend to stand out, making them visible through the lighter

Adjusting the initial tone of a dry surface.

It is possible to add new elements to a finished painting, such as this building.

With the palette knife it is possible to remove a specific area.

colors, especially the whites and yellows.

The Pentimento on Fresco

The pentimento on fresh paint is carried out on both the palette and the canvas. Having removed the thickest impastos with the palette knife, the forms are repainted using the same procedure that was employed from the start of the picture: the corrected zone is redrawn if necessary, then the area is repainted with the same color tone that was used originally and, last, the area is blended into the surrounding chromatisms.

Corrections on Dry Paint

Any work on a dry canvas always entails certain prob-

lems. The texture of the working surface and the darker colors tend to stand out. If we accept these drawbacks, the corrections can be made by applying a new layer of paint over the part to be corrected.

The variations in tone can be changed at any moment.

Having removed the area, it is possible to paint them in again.

The different possibilities for correcting oil depend on how well the artist masters the oil medium.

MORE INFORMATION:

The composition of oil **p. 10**
Blending colors **p. 62**
The delicate work of glazing **p. 68**

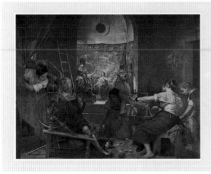

Velázquez, The Great Rectifier

Velázquez was one of the pioneers of free and spontaneous work, which required him to carry out continuous changes. Note in this example (*The Spinners*) the correction to the spinner's sleeve.
In general, it was not so easy to see Velázquez's pentimentos during his day, but with the passing of time they have become more evident.

GLASS AND REFLECTIONS

The wide variety of techniques that can be employed in oil makes it an extremely apt medium for painting objects in great detail. Examples of this abound in portraits, still lifes, and landscapes, in which all manner of elements and textures can be seen. The highlights on an object indicate the material it is made of. A china vase does not have the same type of texture as glass or a piece of fired clay.

Cups and Glasses

The texture, the drawing, and the color have a direct influence on the appearance and volume of glass objects. The drawing is one of the most fundamental aspects, and something that has to be constantly improved until the shapes have been perfectly defined.

As you can see, glass filters color and forms by taking in the chromatism of the surrounding atmospheric light. The highlights make the object's shape stand out against the surrounding elements.

Having roughed-out the canvas, the edges of the glass are drawn with a light tone and a fine brush; if the glass contains a liquid, the surface is painted with a darker tone than the rest, observing the subject's shape and perspective. The transparency of the liquid in the glass will depend on its color.

Highlights are chromatic variations of the glass surface.

A glass accumulates light at its edges.

Drawing the edges of glass.

The intensity of the darkest areas is heightened by highlighting the contrast of the white lights.

Suggesting Volume

The volumes of the different elements of a picture are defined by the contrast and dispersion of lights and shadows.

Light reflects the color of the subject, while the highlights are obtained through contrast—white appears whiter when the surrounding tone is darker.

A shadow is not uniform in color; part of it falls between the semi-darkness and the reflected light. This light zone is located at the edge of the subject and it is more accentuated when the subject is close to a brightly colored object. Usually a shadow is cast over the surface on

Light alters the color of a reflection from a spherical shape.

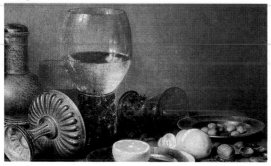

shadow. The shadows model the surface, while the points of light bring out its texture.

Highlights Overcome Presence

Glass objects appear more alive when they are accompanied by a play of lights.

The illuminated zone of a sphere or a cylindrical object is defined by the direction of the light.

It is best to reserve the highlights on glass objects during the roughing-out session.

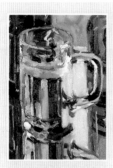

Painting Dense Glass

This glass was painted with a broken range of colors. The glass itself is defined by the variation of contrasts achieved during drawing and in the use of color. The liquid inside the glass is suggested by the volume of the ridges of the glass.

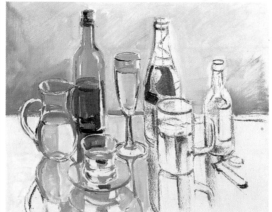

which the subject stands, and tends to appear darker the closer it is to the object.

The volume of spherical bodies can only be obtained by painting zones of light and

By varying the direction in which the light shines on the glass and other objects in your composition you can heighten the presence of the subject.

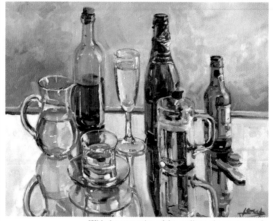

With the exception of the outlines, the contents of a glass is better painted with reflected colors.

The Reflection of Light

Light is caught by glass, creating dark zones and highlights which sometimes become so pronounced as to appear almost solid, growing larger the closer the light is to the object.

When objects are observed through glass, they distort and undergo color gradations, according to the density of the glass.

MORE INFORMATION:

Color blends **p. 62**

The background-figure relationship **p. 70**

FINISHING AND VARNISHING

It is important to know when to finish a painting. Very often, what starts out as a promising picture loses its initial spontaneity through excessive reworking, which ruins the original feeling of the painting.

Once the painting is finished it has to be left to dry for a certain period of time depending on the thickness of the paint. It is essential to ensure that the painting is completely dry before applying varnish, otherwise you may destroy your work.

An unvarnished painting has a mostly matte surface, which lacks chromatic vibrancy.

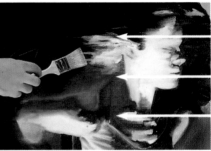

The varnish is applied with a wide, soft-haired brush in uniform strokes.

The Drying Time

Oil generally takes a long time to dry. This is because oil dries gradually, layer by layer, through oxidation.

Even if the paint appears to be dry, it may still be wet deep inside. In fact, some painters apply such thick impastos that the picture takes years to dry completely.

To speed up the drying time you can add paint driers. Not only do these products increase the process of oxidation but can alter the color and structure of the oil.

The best advice is to leave the painting to its natural oxidation process, which varies between six months for thin paintings and one year for denser works.

Alterations

It is always possible to correct an oil painting. However, it is more convenient to do this while the paint is still wet. It is far easier to add or change something while the paint is wet, bearing in mind that each new layer must be thicker than the one beneath it.

Finishing the Painting

It is always difficult to know exactly when a picture is finished. The painter may fall into the trap of overworking the picture with too many hues.

Before you finally decide whether or not the painting is complete, leave it somewhere out of sight for a few days. When you come to re-examine it, you will see it more objectively.

Types of Varnish

Many artists do not like the finish that oil has, because it usually dries with an unpleasant variation of matte and gloss surface. There are several types and qualities of varnish.

If you are a beginner, we recommend you choose from the better known brands; within these you can find both gloss and matte varnishes.

Applying the Varnish

It is essential to let the painting dry before you apply varnish; how much time depends on the thickness of the paint on the picture.

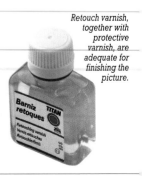

Retouch varnish, together with protective varnish, are adequate for finishing the picture.

Varnish can be applied in various ways, depending on how it is packed. If it comes in a glass bottle, you will have to apply it with a soft hair brush in order to avoid adding a texture. The varnish has to be painted in a thin, even layer over the surface.

Varnish is also available in aerosol form, a simple and efficient system since all you have to do is spray a fine layer evenly over the surface. One way of checking that no parts have been left unvarnished is to observe the surface from a side angle.

Cleaning Old Paintings

Old paintings tend to yellow and get dirty. To clean them you need patience and technique. A complex problem to solve is knowing when some cleaning agent has made its way through the varnish and is eating into the paint itself.

To remove dust and grease, you should lightly wet a piece of cotton cloth in turpentine and lightly clean the affected areas in small circular move-

Restoration and Lght

Rembrandt (detail), *The Night Watch.*

This painting got its name by error. The reason was that after it had been cleaned and restored it was observed that a dense layer of paint had darkened to such an extent that the painting had turned into a nighttime work.

ments. Then the cleaned area should be gone over with a clean piece of cloth.

Once the painting is clean, if you want to apply a new layer of varnish, you can remove the original layer with a solvent comprising five parts alcohol, three parts turpentine and one part of ethyl acetate. Follow the instructions mentioned earlier using a cotton cloth, while

keeping an eye on it for signs of color pick up. At the slightest indication of paint, use another piece of cotton cloth soaked in turpentine and gently rub over the affected zone. (It is important to bear in mind that this task can take hours and, once started, must be completed in the same session.)

Increase in color contrast.

Depth in the blacks.

Effects of a correct varnishing.

Shine in the whites.

Highlighting the blends.

MORE INFORMATION:

The composition of oil. Resins and pigments **p. 10**

Note: The titles that appear at the top of the odd-numbered
pages correspond to:
The previous chapter
The current chapter
The following chapter